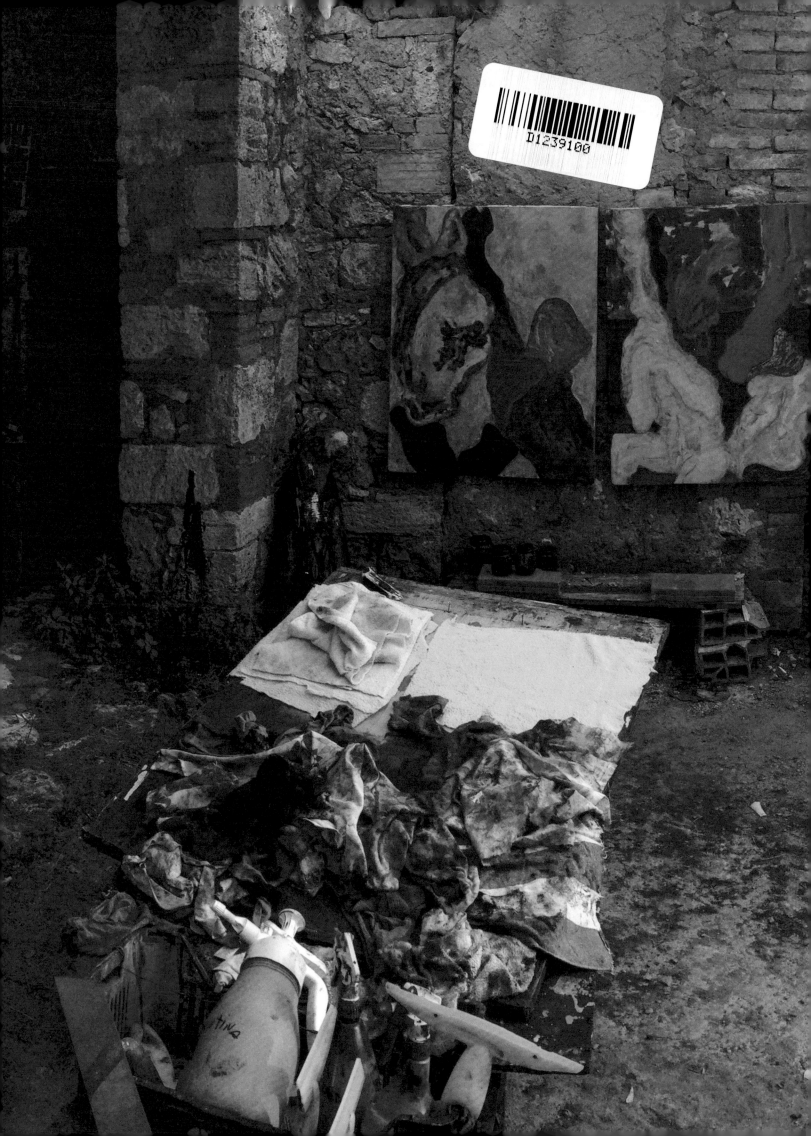

BILL JENSEN

TRANSGRESSIONS

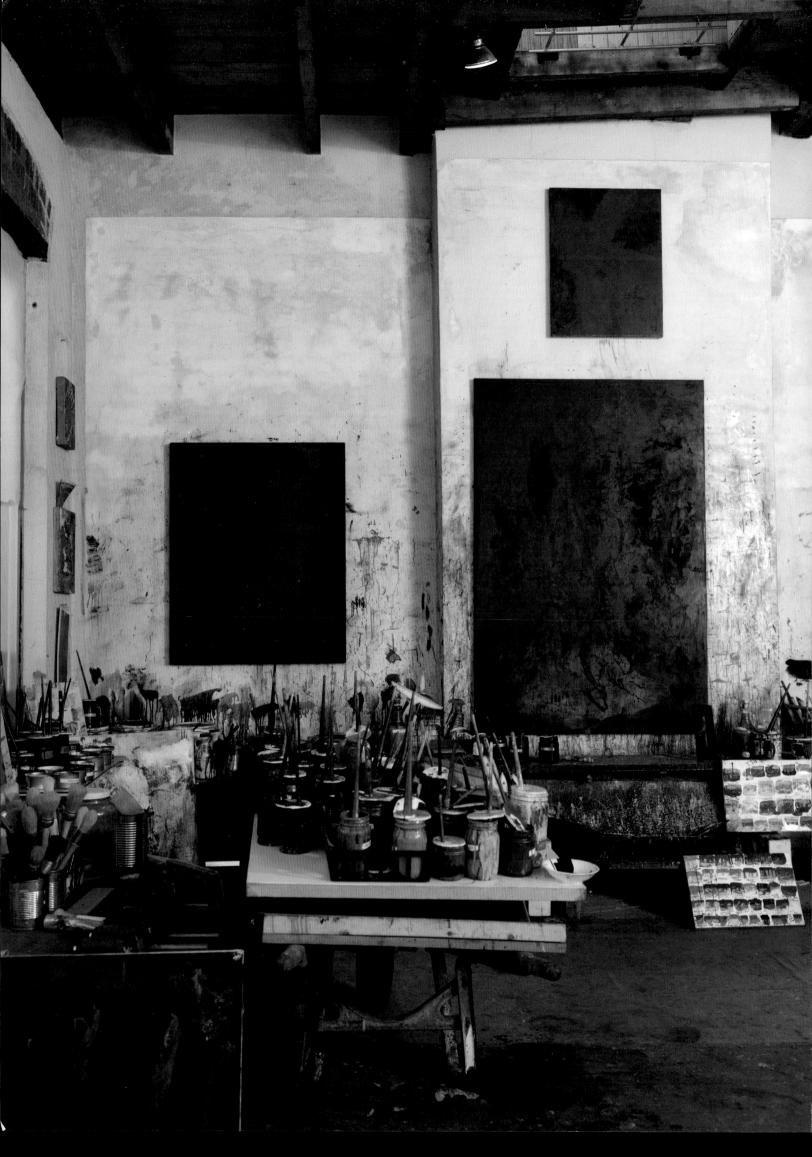

BILL JENSEN

TRANSGRESSIONS

CHEIM & READ, NEW YORK

PASSAGES ON BILL JENSEN'S TRANSGRESSIONS
DAVID LEVI STRAUSS

Bill Jensen has been crossing lines and boundaries as an artist for almost half a century. To do that effectively and survive, one must first know where the lines are, where they come from, and how they are made. Some of these lines are formal, some are cultural, and some are philosophical. Jensen is one of the principal contemporary inheritors of a rich tradition of abstraction in American painting, but he is also one of its most inventive interrogators, finding a myriad of ways to extend the inquiry by anxiously and bravely testing the limits and edges of things.

Transgression, I think, ought to be applied only to an act committed, not because of a want of sensibility, but, to the contrary, knowingly, despite the toll it is certain to exact . . . In its essentials and in its practice, only art expresses that prohibition with beseeming gravity, and only art resolves the dilemma. It is the state of transgression that prompts the desire, the need for a more profound, a richer, a marvelous world . . .
—Georges Bataille[1]

The Last Judgment

The title of Jensen's exhibition at Cheim & Read gallery in the spring of 2015, *Transgressions* (crossing lines, exceeding due bounds or limits), comes from a series of paintings Jensen made from 2011 to 2014 responding to the depiction of human bodies in Michelangelo's *Last Judgment* frescoes for the altar wall of the Sistine Chapel of St. Peter's Basilica in Rome.

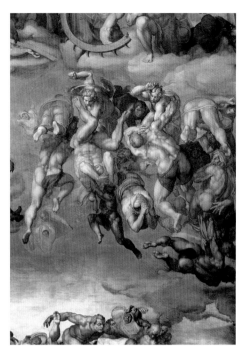

Michelangelo, *Last Judgment* (detail)

In the sixteenth-century originals, these naked bodies, both damned and saved, are forcefully extended into an exaggerated muscular array that joins body to body in polymorphously perverse strings. It is no wonder that these painted bodies were censored repeatedly, from the beginning. As Leo Steinberg wrote in *The Sexuality of Christ in Renaissance Art and in Modern Oblivion*:

Usually, where serious art is arraigned, the censor's hand spares the whole on condition of partial smothering or mutilation; examples of which may be studied in any public museum, but most instructively on the surface of the Sistine Chapel's *Last Judgment*, punctuated throughout by the fuss of loinbibs and underwear. As a grudging alternative to total obliteration, Michelangelo's nudes were twice painted over in his own century—to be further overpainted in the 18th.[2]

The *Last Judgment* was controversial from the beginning, for many reasons. It is, after all, a thoroughly pagan painting, by a Neoplatonist, placed at the center of the greatest church in all of Christendom. Some believe it ultimately, blasphemously, asserts the primacy of art over faith, both materially—wantonly lavishing ultramarine blue pigment from Afghani lapis lazuli, dearer than gold, over the entire background—and in

content. Others believe it was also intended to establish Michelangelo's superiority over all other painters of the time, especially Titian, whom Michelangelo's supporters accused of being too slavishly realistic in his imitation of nature, and of not understanding the importance of *disegno* (design, drawing) in art. In this realm, as well, Michelangelo's extravagant use of lapis ultramarine in the *Last Judgment*, which only appears in bits of sky in Titian, was seen as a pointed challenge.

In Jensen's *transgressions* (as distinct from *translations*) of these works, begun as sketches in Rome, Michelangelo's bodies are abstracted into fleshy fields bound by thick contour lines that obscure the boundaries between distinct bodies even further, and accentuate their rising and falling movement. Jensen zooms in on an area in the lower right portion of the fresco, where castigating angels cast down the damned, and flips the scene upside down to increase the sense of disequilibrium. Individual bodies are melded into seething, continuous, twisted columns of flesh in transit. The result is thrillingly brash and disorienting.

The two painted diptychs, *Transgressions (Black and White)* (plate 2) and *Transgressions (Flesh)* (plate 3), and *Transgressions (First Study)* (plate 4), the studies for the right and left panels of those paintings, with their bold cobalt orange fresco-like grounds and complex skin tones, again bound by thick dark lines, all from 2013, are informed, as is often the case in Jensen's work, by the artist's etchings of these subjects. The ability in printing to reverse and flip images leads to a new fluidity of forms.

The triptych that opens this exhibition, *Transgressions* 2011–14 (plate 1), placed in the vaulted anteroom directly opposite the main entrance of the gallery, consists of two panels of attenuated line drawings of the repeated masculine (and ithyphallic) mass body images on a lighter fleshy ground, flanking a glowing, pulsating, blood-red vagina or exploding supernova. This transgression both honors and challenges the bases of the source.

From the outset then, in the *Transgressions* series, Jensen's relation to a source image is foregrounded, as it often was with his predecessor Willem de Kooning. Sources from the history of painting continually opened up new areas of inquiry in de Kooning's work and allowed him to constantly reinvent himself. These images often included extreme body images, because, as the painter said, "Even abstract shapes must have a likeness," and "Flesh was the reason why oil painting was invented."[3]

Vertebrae of the Spine, Drawn

The spine of this most recent body of Jensen's work is formed from the diptychs and especially the triptychs here, beginning with the *Transgressions* triptych, which is an explosive image of origin. At the other end of the progression, in the last room of the exhibition, is the *Thoughts Never Twisty (Confucius Quote)* triptych, 2013–14 (plate 24) (in the *Analects*, Confucius says, "There are 300 songs in the *Book of Songs*, but this one phrase tells it all: thoughts never twisty"),[4] with the central ghostly image derived from the outline or afterimage of the three

figures in Andrei Rublev's *Trinity* icon from the fifteenth century, in black and white, flanked by two luscious dark panels in Egyptian violet, almost iridescent.

Andrei Tarkovsky's film *Andrei Rublev*, 1966, which at times is played continuously in Jensen's studio, is one of the most powerful works ever attempted on the conflict between art and faith. The film was shot entirely in black and white, until the very end, when Rublev's paintings are brought to life in luminous, breathtaking color. In the *Thoughts Never Twisty (Confucius Quote)* triptych, Jensen reverses the schema, evoking the memory of color through the dark. When one looks from the dark outside panels to the black and white image between them, the afterimages appear in color.

Above Jensen's abstract extension of the three seated angels who visited Abraham at the Oak of Mamre in the *Trinity* icon appears a roughly incised drawing of a primitive structure, like the one that appears in the upper-left corner of Rublev's icon, or like a simple temple from

Still from Andrei Tarkovsky's *Andrei Rublev*, 1966

a Shih-tao landscape. In Jensen's transcultural imaginary, inscriptions flicker through time and space.

Between *Transgressions* in the anteroom, and *Thoughts Never Twisty (Confucius Quote)* in the last room, appears the *Loom of Origins* triptych, 2014–15 (plate 5), in the center room. This image first appeared, again, in prints, and in the *Book of Songs I* diptych in 2010–11, and is repeated here three times in vibrant blue, orange, and acidic yellow-green. The outside panels mirror the central one, but in a very different palette. *Double Sorrow +1 (Grey Scale),* 2014–15 (plate 6), repeats the same figures that appear in *Loom of Origins*, but this time in black and white and shades of gray (presaged also in 2010–11, in *Black Sorrow (I)*). Jensen told me that *Double Sorrow* contains something like 300 different shades of gray. Jensen's modulation of light and dark is one of the most thrilling enactments of this work.

The space between the abutted canvases in all of the triptychs and diptychs is carefully calibrated, and varies according to color and image. The offsetting of frames is inspired by the fitting of altarpieces around Renaissance altars, and more recently by the cuts in a three-paneled painting from 1960–61 by Ronald Bladen, and his *Three Elements* sculpture from 1965 (Jensen first helped Bladen install his sculptures in 1972; they became life-long friends, and Bladen is a recurrent source of inspiration for the painter), and from a rare de Kooning commission, a three-paneled altarpiece from 1985, that appeared in the de Kooning

retrospective at the Museum of Modern Art in New York in 2011. The variable offsetting of Jensen's diptychs and triptychs increases the sense that the paintings don't have fixed edges or ends, and the multi-panel method allowed the painter (and now the viewer) to move beyond the limitations of the frame.

Colorito Over Time

In the large center room of the gallery, color reigned. The vibrant reds, greens, and blues here—pure cadmiums and cobalts—are influenced by Jensen's time spent in North Africa, and signaled by the titles *Tuareg* (plate 10) and *Tamascheck* (plate 9), both from 2013. All are infused with the color and light of the Malian savanna.

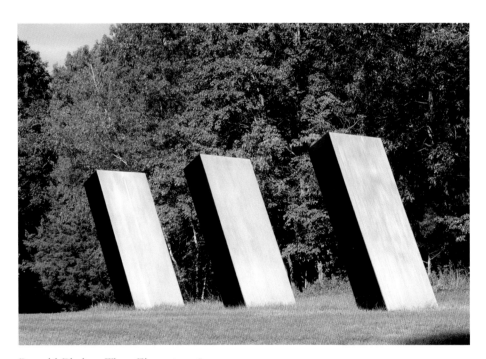

Ronald Bladen, *Three Elements*, 1965

Willem de Kooning, *Triptych (Untitled V, Untitled II, Untitled IV)*, 1985

These exuberant excursions in color, illumination, and calligraphic brushwork are offset by several more somber and reflective, inward-looking works that were clearly built up over considerable time. The ethereal eidolon in *Message*, 2011–14 (plate 15), is a depleted body, reduced to limbs and torso, morphing into a lovely face, lips parted to speak. These paintings have aged, weathered surfaces that show the distress of time spent as studio tables, complete with remnant paint can rings: grounds with a history. The beings that appear in these paintings seem always to have been there, but have come up to the surface over time.

Worthy Ones

Jensen's first *Luohan* paintings were made in 2003, and the brushy dioxin violet seed of the current iterations can be found in *Images of a Floating World (Walk of Woe)*, from 2008–09. The Luohan (Sanskrit: *arhat*) are the "worthy ones," who have attained much on the path of Enlightenment. They are often thought of as disciples of Buddha, and personifications of points along the Path. Their depiction in Chinese art from the ninth century on evolved especially in the context of Zen.

The strikingly anthropomorphic forms of *Luohan (Violet I, II, and III)* are achieved with an incredible economy of means reminiscent of Sung dynasty brush paintings. *Violet 1* (plate 16) portrays a shaggy-headed sage from behind, bundled up and hunched against the cold, while *Violet II* (plate 17) depicts a long-haired, bearded Luohan centaur or *kinnaras* turning to address a smiling figure just coalescing into a body.

Still & Limitless

The two diptychs *Stillness*, 2012–14 (plate 13), inspired by Italian drapery, and *Double Stillness*, 2014–15 (plate 14), inspired by the robes of a Buddha statue, introduce a rare object-oriented delicacy to Jensen's work.

The left panel of the *Stillness* diptych, 2012–14, is heavily impastoed, and the right panel is cut by a streak of crimson, like an open wound. This, signaled in the title, is an homage to Clyfford Still, who was there for Jensen from the beginning. On a school field trip from Edgewood Junior High to the Minneapolis Institute of Arts when he was perhaps 12 years old, Jensen wandered away from the group into a room on the second floor, where he found Chaim Soutine's *Carcass of Beef*, 1925, Max Beckmann's massive *Blind Man's Bluff* triptych, 1945, and a medium-sized painting by Still. Jensen told Ronald Bladen, and later Chris Martin: "There was something in this room that introduced me to the modern world."[5] Through the visceral involvement of Soutine (the body opened out, incarnate), the complex image symbolism of Beckmann, and the primordial space of Still, Jensen has continued to complicate and *transgress* the modern.

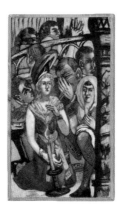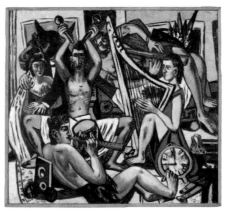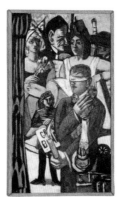

Max Beckmann, *Blind Man's Buff*, 1945

Clyfford Still's paintings move beyond the edges, so that, perceptually, his canvases seem not to have them. It is as if something is moving through the painting—the world, visible and invisible, moves through the work, so we are no longer bound by the edges of the frames.

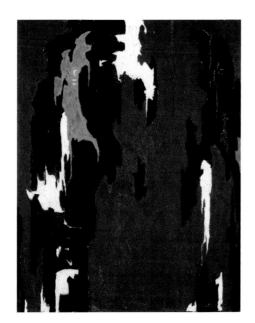

Clyfford Still, *PH-945*, 1946

This limitlessness is freeing, but it is also dangerous, because it can open onto limitless pain, limitless grief, limitless sorrow. So, in the end, it has to come from joy, from hope. Even Goya's late black paintings come, ultimately, from hope. If they didn't, we couldn't bear them. As it is, we can just barely do so.

Michelangelo's *Last Judgment* gets to the limitless differently, through scale and volume and sheer embodiment. In it, we get an endless present, the final moments of all human existence, in a world of sky (that inexhaustible lapis) and bodies—an expanding vision of faith, playing against the fixed verities of good and evil, but also, in the elimination of a traditional frame, the introduction of a new, ultimately modern, sense of uncertainty and doubt.

Much of our current language of belief is invested in what we hold most dear: money. To be "credit-worthy" is to be worthy of belief, believable (Latin: *credere*, to believe).

When the Portuguese painter and architect Francisco de Holanda traveled to Italy in 1538–40, he recorded several discussions he had with Michelangelo (in advance of Vasari's *Lives*). At one point, Francisco asks Michelangelo how paintings should be valued, and the Italian artist complains about the then current practice of valuing paintings in monetary terms. "That valuation is very foolish," he says, "which is made by one who does not understand the

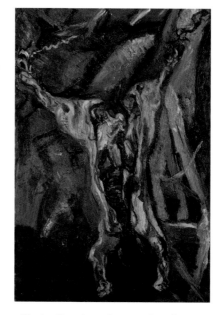

Chaim Soutine, *Carcass of Beef*, 1925

good or the bad in the work." And later on he avers that "what one has most to work and struggle for in painting is to do the work with a great amount of labor and sweat in such a way that it may afterwards appear, however much it was labored, to have been done almost quickly and almost without any labor, and very easily, although it was not. And this is a very excellent beauty."[6]

Clyfford Still's Jaguar

The last time I was in the Rothko Chapel in Houston, earlier this year, there was a man sitting on one of the benches in front of the paintings, staring into his iPad, never looking up, for an hour. Curious, I walked behind him, and saw Rothko's paintings there on the screen. The man's faith in technology was complete and all-encompassing, and it protected him from the limitlessness of the paintings that surrounded him.

The kind of seeing that happens when we look at Bill Jensen's paintings is an embodied seeing. It presses the eye and mind into risky regions where the usual habits of perception must yield. It is dangerous territory, but the yields are significant.

Empty & Full

Over the past two decades, Jensen has found fertile ground for his art in the traditions of ancient Chinese painting, including the idea and aesthetic of *emptiness*. Perhaps the clearest and most expansive exegesis of the concept for the West is François Cheng's *Empty and Full: The*

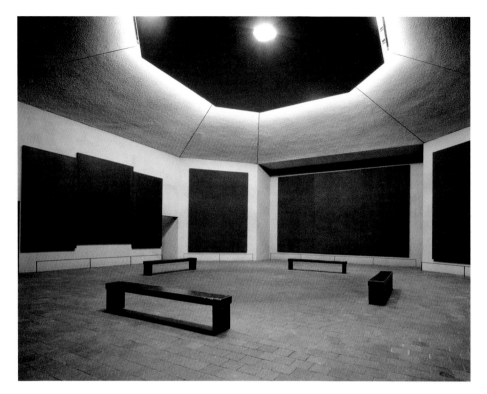

The Rothko Chapel, 1971

Language of Chinese Painting, published in French in 1991 and in English translation in 1994. Cheng was born in China in 1929, but has lived in France since 1948, and writes poetry, novels, and essays, in addition to books on art, all in French. He worked closely with Jacques Lacan on classical Chinese texts in the sixties and seventies, and was the first person of Asian origin to become a member of the Académie française, in 2002.

"Emptiness," writes Cheng, "introduces discontinuity and reversibility into a given system and thus permits the elements composing the system to transcend rigid opposition and one-sided development."[7]

Painting is involved directly in the stuff of cause and effect, but it can get stuck in a one-way movement from one to the other. In ancient Chinese painting, emptiness is the invisible and fullness is the visible, and you can't have one without the other, because they are in a constant state of *reciprocal becoming*. Another very important part of this schema is the fact that images arise from emptiness.

Color is also a big part of this. The old Buddhist-inspired phrase is "Color is emptiness; emptiness is color," where "color refers to the shimmering manifestation of the phenomenal world."[8] Jensen crosses lines with color—the fullness of line inflected with the emptiness of color.

It turns out that black is not as empty as purple or violet. Jensen demonstrated this to me in the studio, holding a black panel next to the deep purple of one of his triptychs. I didn't understand it, but I saw it. And having seen it once, I could see it again, in a Clyfford Still painting, *PH-241* from 1949 at the Museum of Fine Arts, Houston, a few months later.

In the Dark

In the last room of the Cheim & Read exhibition were Jensen's dark paintings, including the *Dark Dragon Pool* series, inspired by a sixteenth-century Chinese guide to every rock, peak, pool, and tree in the Yellow Mountains. Jensen has been making these tenebrous landscape-inspired paintings, with subtle color changes and dramatic tones of viscosity and

texture, for at least a decade, but these new *Dark Dragon Pool* paintings, with their deep Spanish Earth browns, silky dioxin violets, iron oxide purples, and gray umbers, get to places previously unseen. Coming into the room, it takes some time for one's eyes to adjust to the hues, and then things begin to appear, in the *speculi.*

In *Now I Believe It Peak (Huangshan Mountain),* 2014–15 (plate 22), the surface becomes iridescent, changing from damson to green as the light strikes it from different angles. In *End of the Ordinary Realm (Huangshan Mountain),* 2013–14 (plate 23), the smoke and flames of a campfire rise and flicker over the surface, from bottom to top and left to right. Standing before it, one can almost smell the smoke and hear the crackling of the wood.

Jensen, Ryman, Transgression

When Bill Jensen was inducted into the American Academy of Arts and Letters in 2014, the award read: "Bill Jensen makes luminous and visionary paintings which seem to express unabashed longing for the transcendental in post-modern darkness. His paintings glow like beacons of lost faith." This statement, from May 1997, might have been written by Robert Ryman. If so, the feeling is mutual. Jensen has called Ryman "perhaps the most sophisticated artist working today and at the same time the most innocent and naïve." The lightness and clarity that Ryman achieves through his singular devotion to material is akin to the way Jensen gets to spirit through matter. Turning matter into spirit and vice versa has driven art, and especially painting, from the beginning.

Limitations, Still

We are in a period right now when some of the managers of art have lost faith in this process, and are positing an end to it. Over the past two hundred years or so, since the invention of technical images, this eschatological urge has almost always been projected onto painting, so that the Death of Painting has become a reliably recurring trope of criticism. The fact that it recurs with such regularity should tell us something about the kind of death being projected. It is a kind of temporary, reflexive suspension of the task at hand, based on a curious mixture of timidity and arrogance.

Bill Jensen stays with a painting until something happens, and then he pays attention to what is happening—physically and materially. In becoming more material, the possibility of the immaterial arises. This is the "reciprocal becoming" of emptiness and fullness. As Cheng has it, "Emptiness introduces internal discontinuity into the linear and temporal development of the picture." This is how painting touches the atemporal—not through forgetting, and thus invalidating, what has come before.

Robert Ryman, *Untitled*, 1961

What is it we want and need from painting, now? We want and need it to transgress the limitations of the body and mind, through the limitations given to us, still.

[1] Georges Bataille, *Lascaux, or the Birth of Art*, translated by Austryn Wainhouse (Lausanne, Switzerland: Skira, 1955), p. 37–38.

[2] Leo Steinberg, *The Sexuality of Christ in Renaissance Art and in Modern Oblivion*, Second Edition, Revised and Expanded (Chicago and London: The University of Chicago Press, 1996), p.185.

[3] Willem de Kooning, "The Renaissance and Order," talk delivered at Studio 55, on 8th Street in New York, Autumn 1949.

[4] In the prefatory note to his translation of the *Analects*, Ezra Pound wrote, "Points define a periphery. What the reader can find here is a set of measures whereby, at the end of the day, to learn whether the day has been worth living."

[5] "In Conversation: Bill Jensen with Chris Martin," *Brooklyn Rail*, February 2, 2007.

[6] Francisco de Holanda, *Dialogues with Michelangelo*, based on a translation by C.B. Holroyd, published in a revised edition in 1911.

[7] François Cheng, *Empty and Full: The Language of Chinese Painting*, translated by Michael H. Kohn (Boston & London: Shambhala Publications, Inc., 1994), p. 36.

[8] Cheng, p. 81.

Transgressions

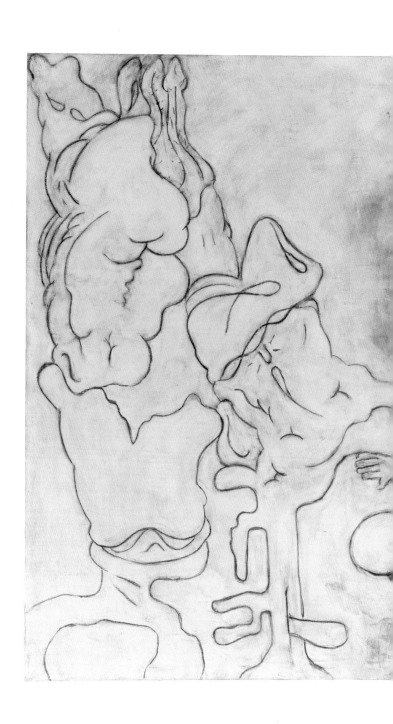

1. Transgressions 2011–14 oil on linen triptych 55 1/2 x 105 in 141 x 266.7 cm

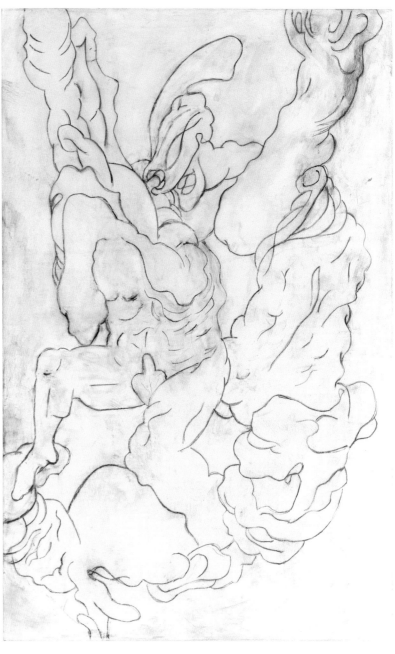

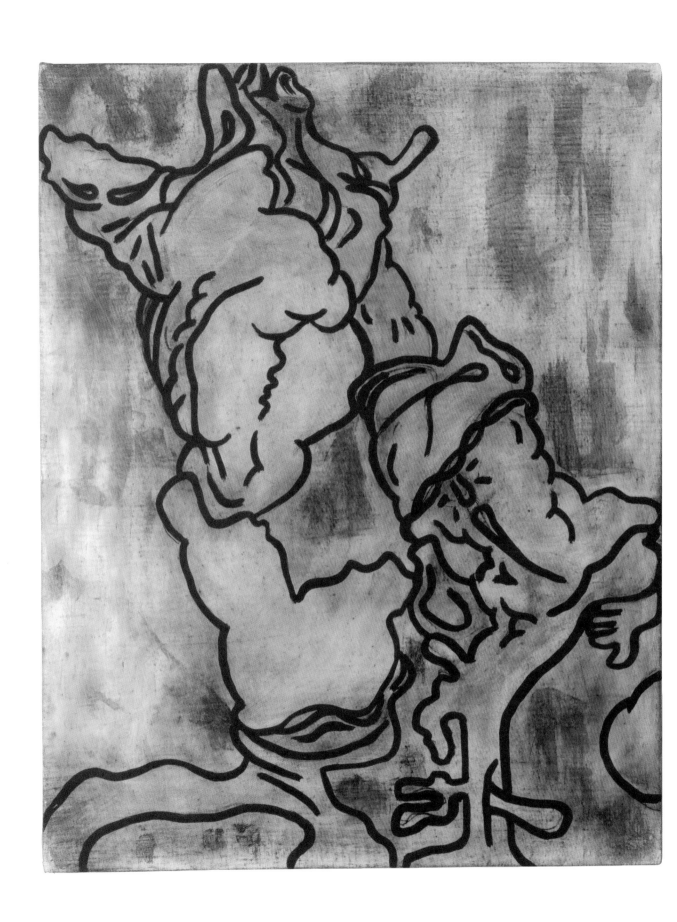

2. Transgressions (Black and White) 2013 oil on linen diptych 40 1/8 x 64 in 101.9 x 162.6 cm

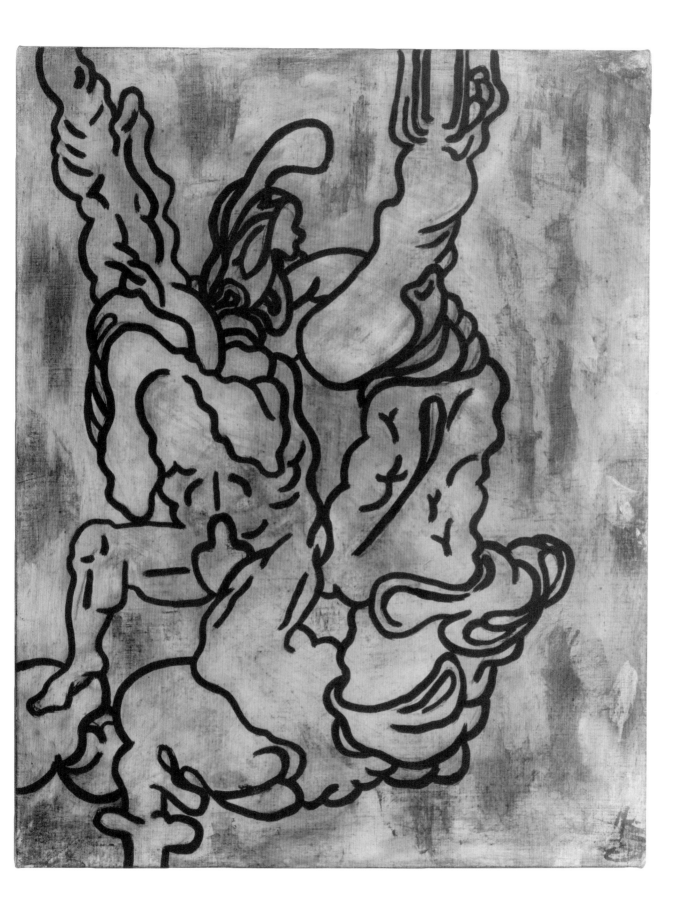

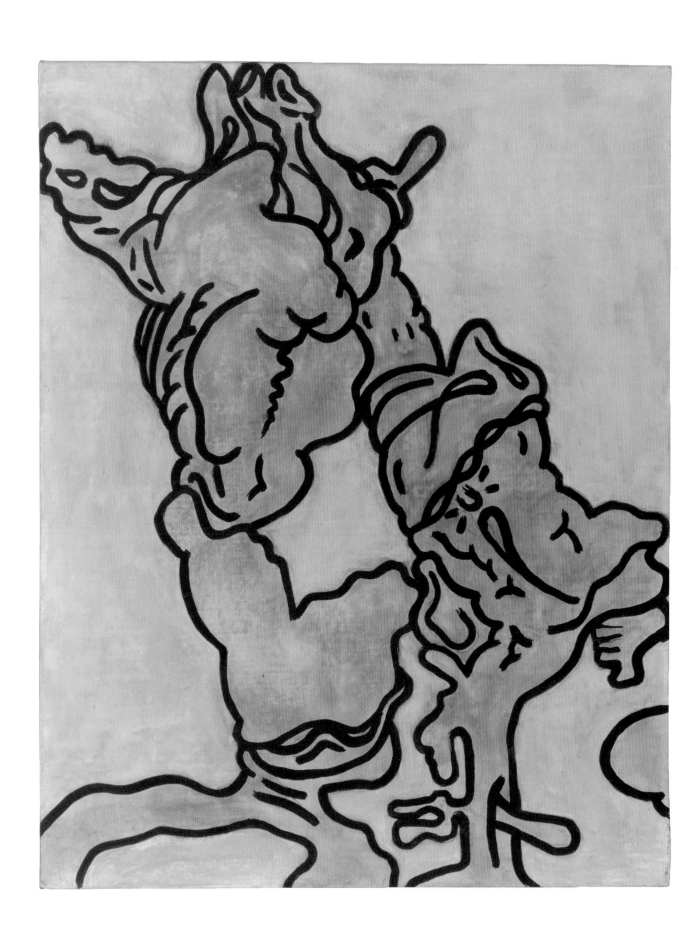

3. Transgressions (Flesh) 2013 oil on linen diptych 40 1/8 x 63 3/4 in 101.9 x 161.9 cm

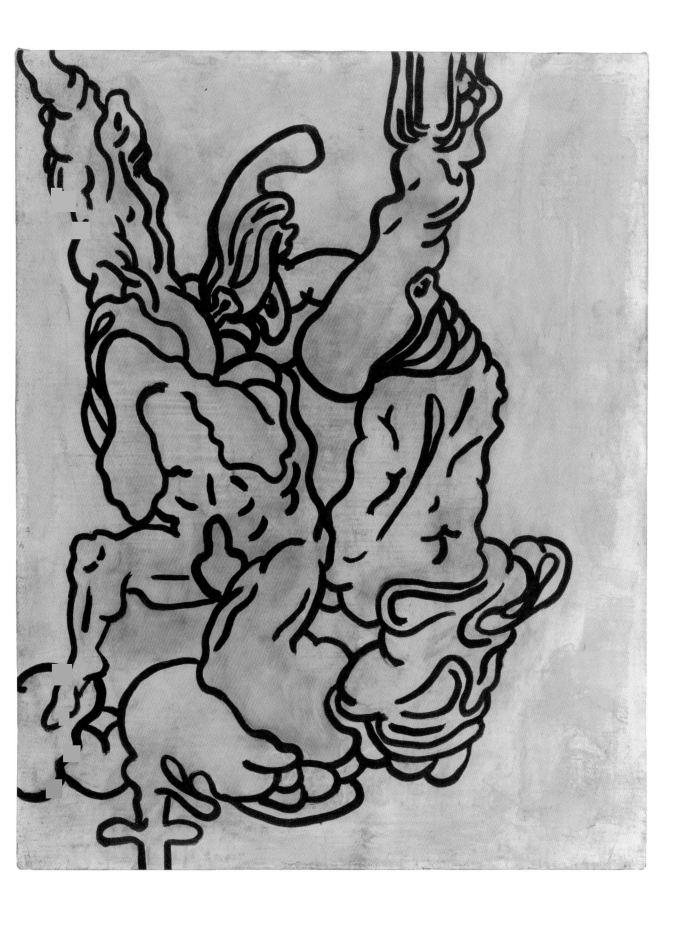

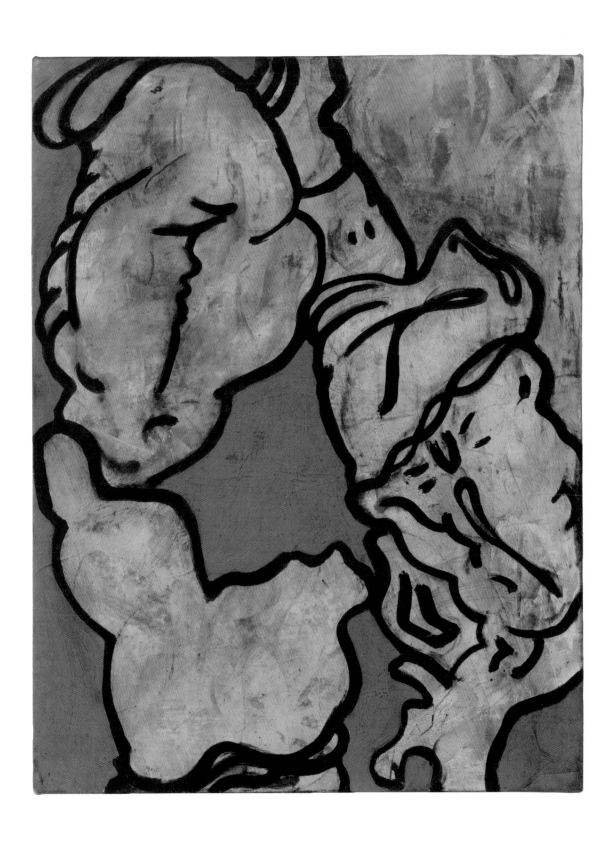

4. Transgressions (First Study) 2013 oil on linen diptych 28 1/4 x 43 in 11.1 x 16.5 cm

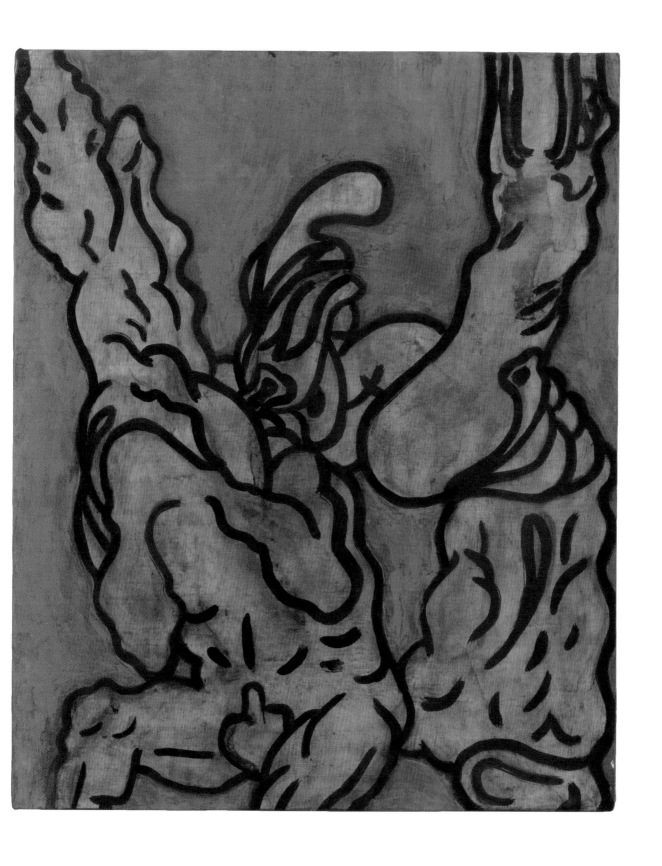

Loom of Origins

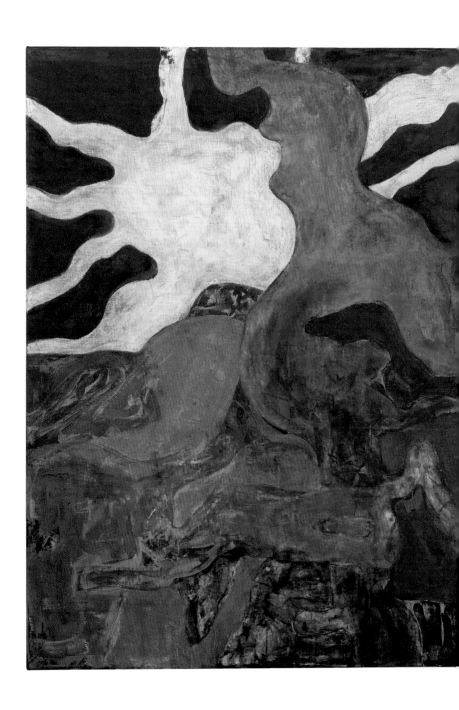

5. Loom of Origins 2014–15 oil on linen triptych 62 x 123 1/2 in 157.5 x 313.7 cm

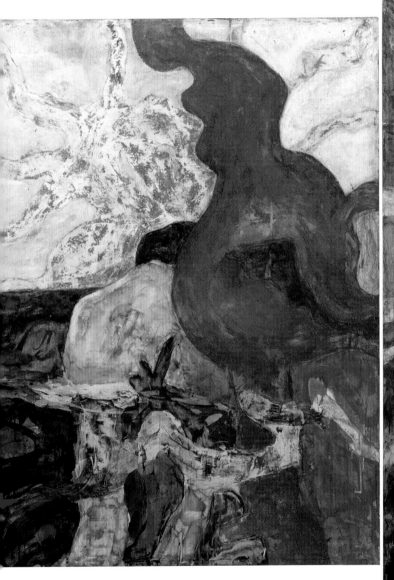
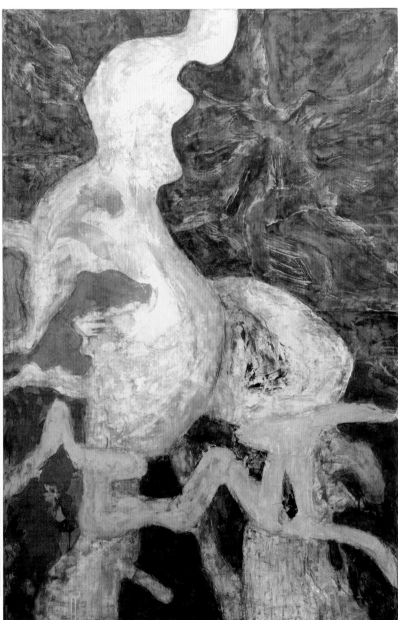

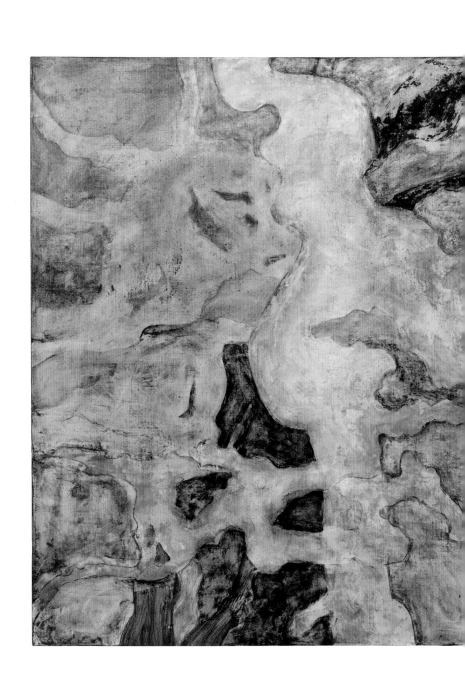

6. Double Sorrow +1 (Grey Scale) 2014–15 oil on linen triptych 58 x 129 in 147.3 x 327.7 cm

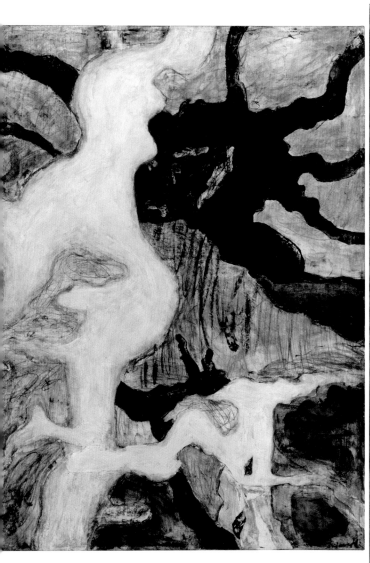
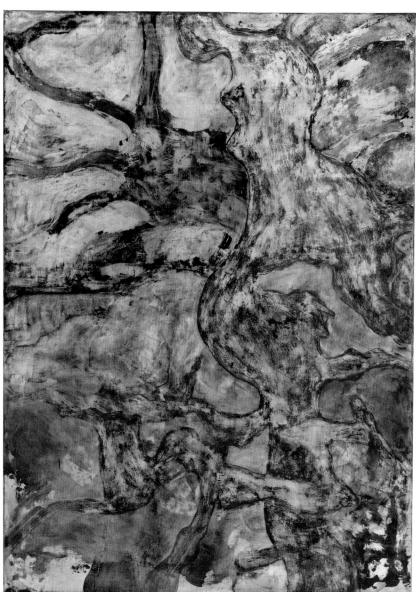

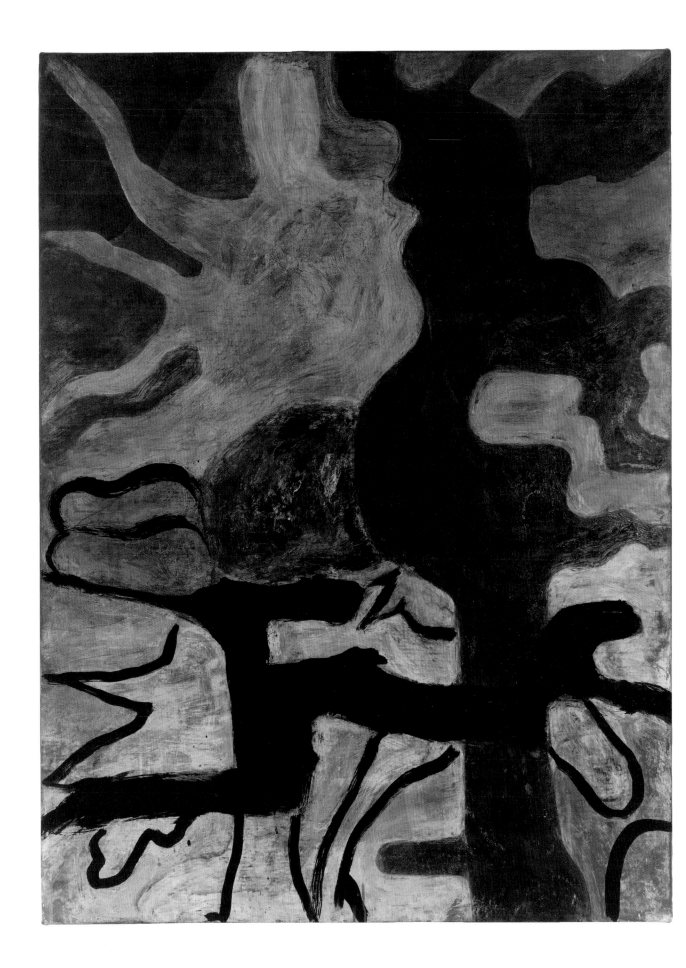

7. Book of Ch'u 2011–12 oil on linen diptych 56 5/8 x 86 in 143.8 x 218.4 cm

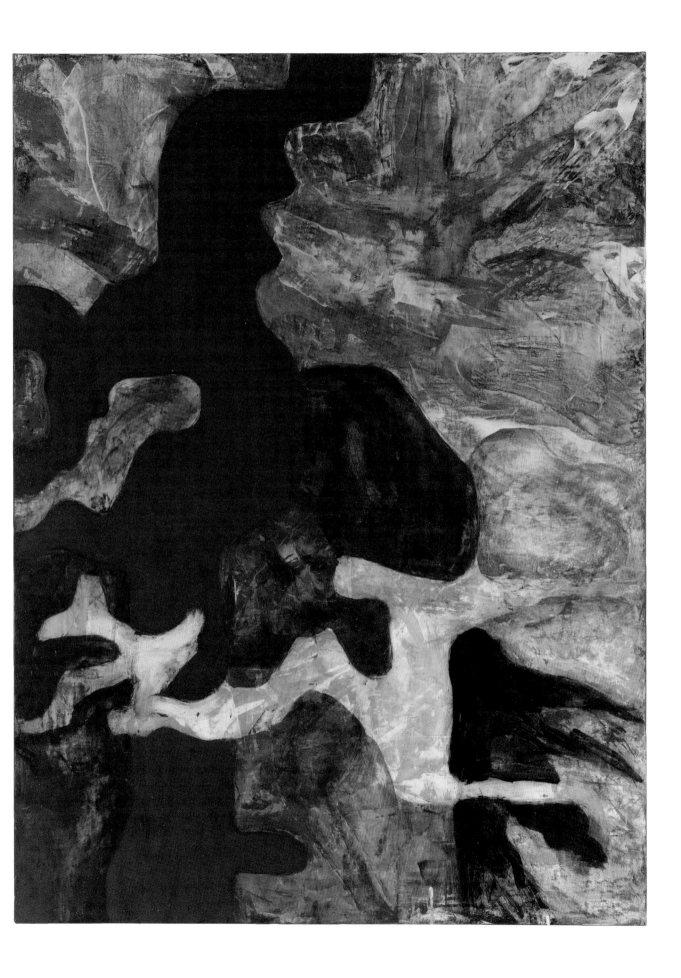

8. Single Ch'ou 2014–15 oil on linen 54 x 42 in 137.2 x 106.7 cm

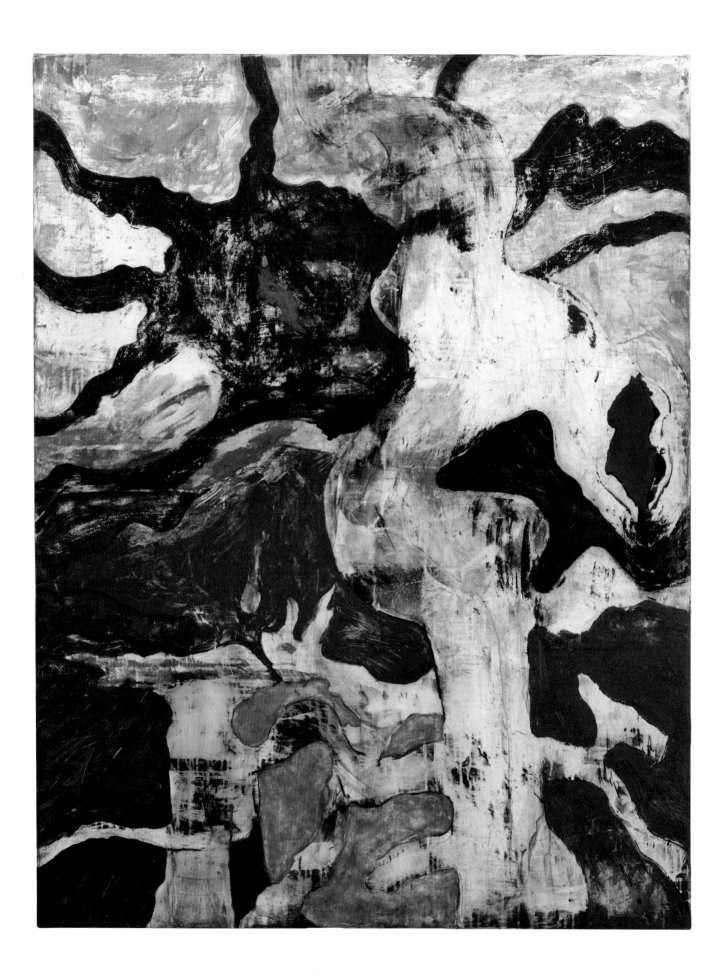

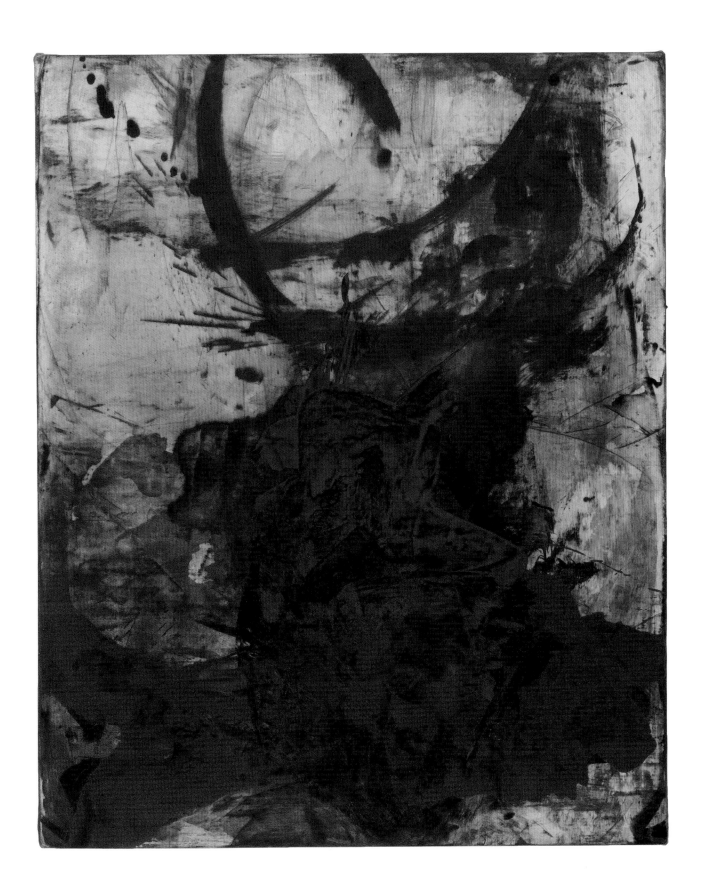

10. Tuareg 2013 oil on linen 28 x 23 1/4 in 71.1 x 59.1 cm

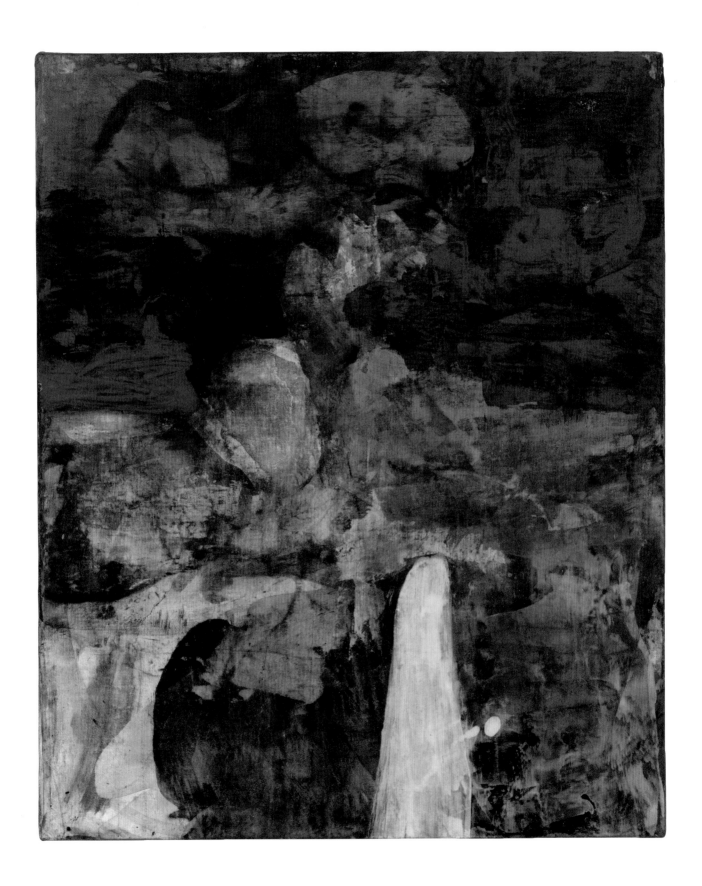

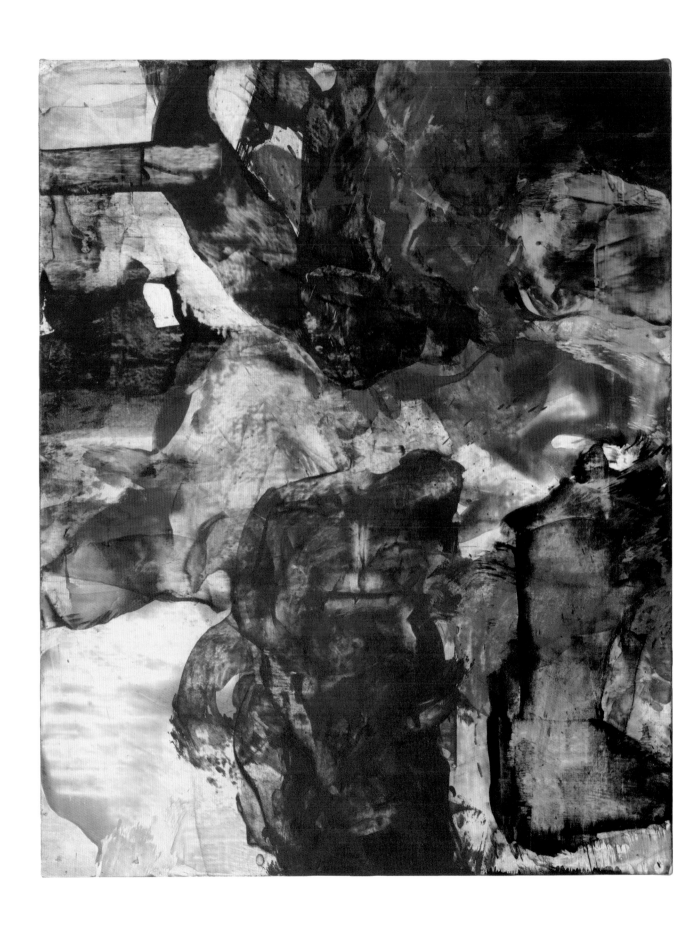

11. Mountain Tiger/Sky 2013 oil on linen diptych 40 x 64 in 101.6 x 162.6 cm

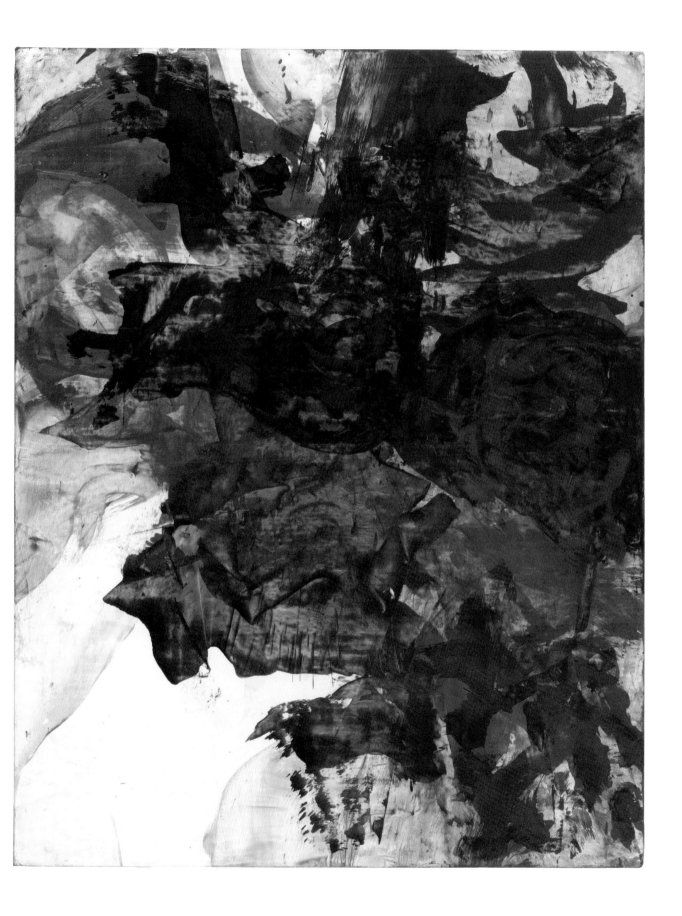

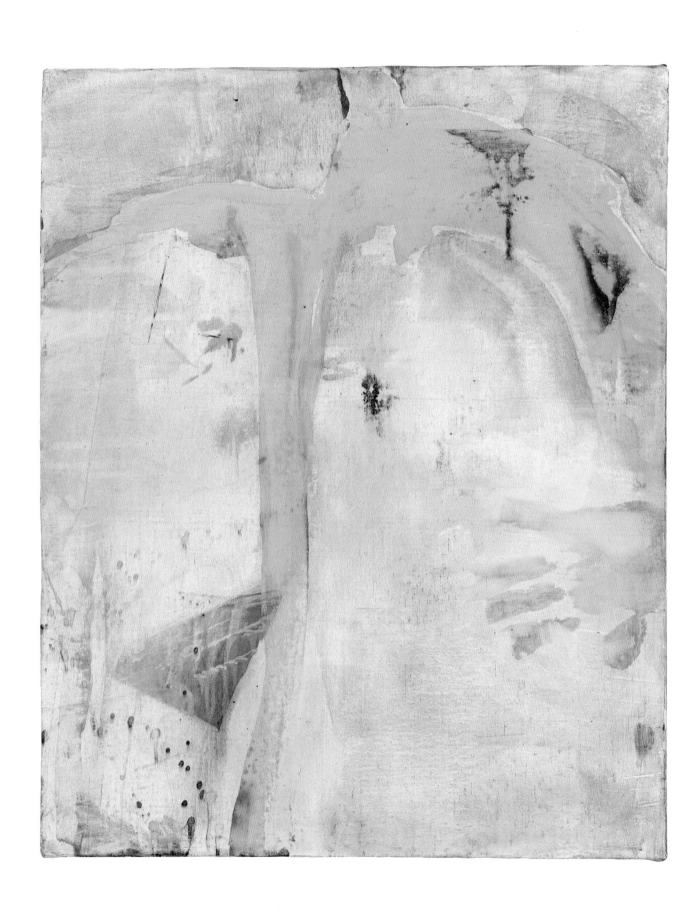

12. Angelico, Angelico 2012–15 oil on linen diptych 28 x 51 in 71.1 x 129.5 cm

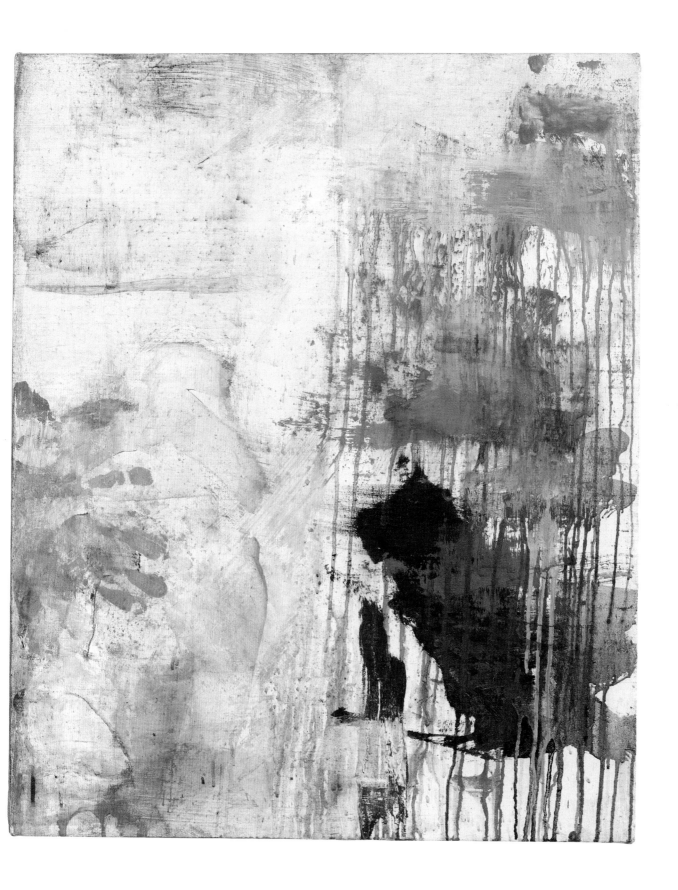

Stillness

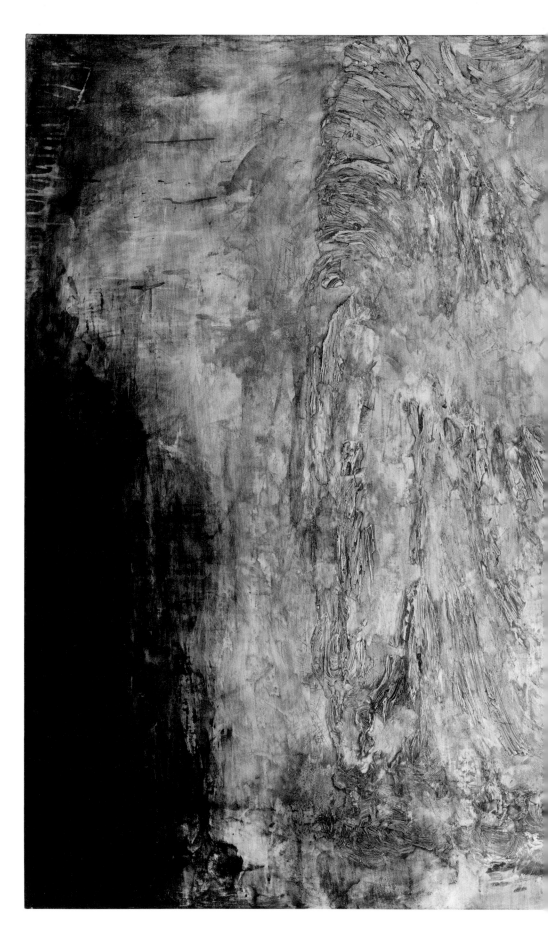

13. Stillness 2012–14 oil on linen diptych 53 1/2 x 74 3/4 in 135.9 x 189.9 cm

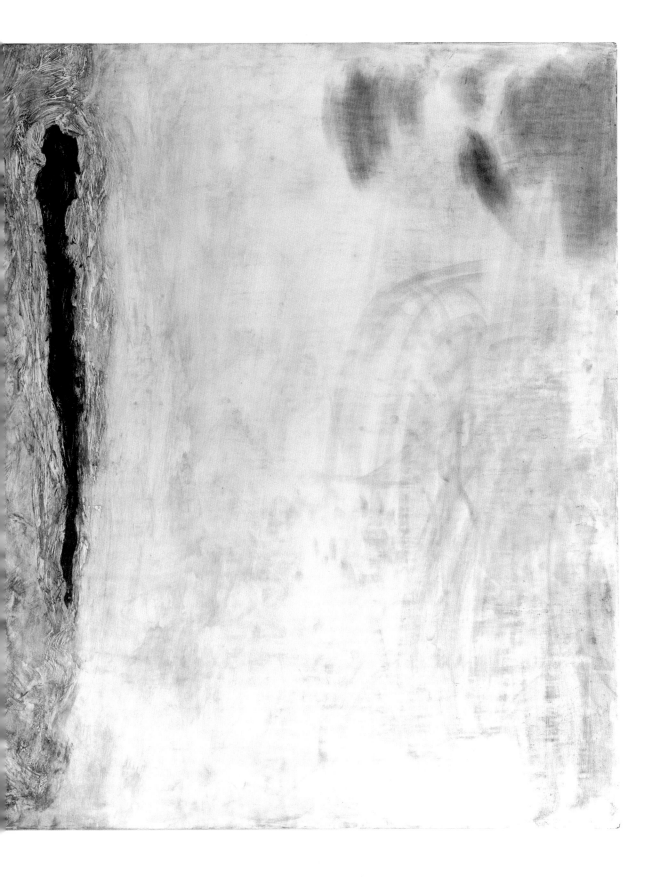

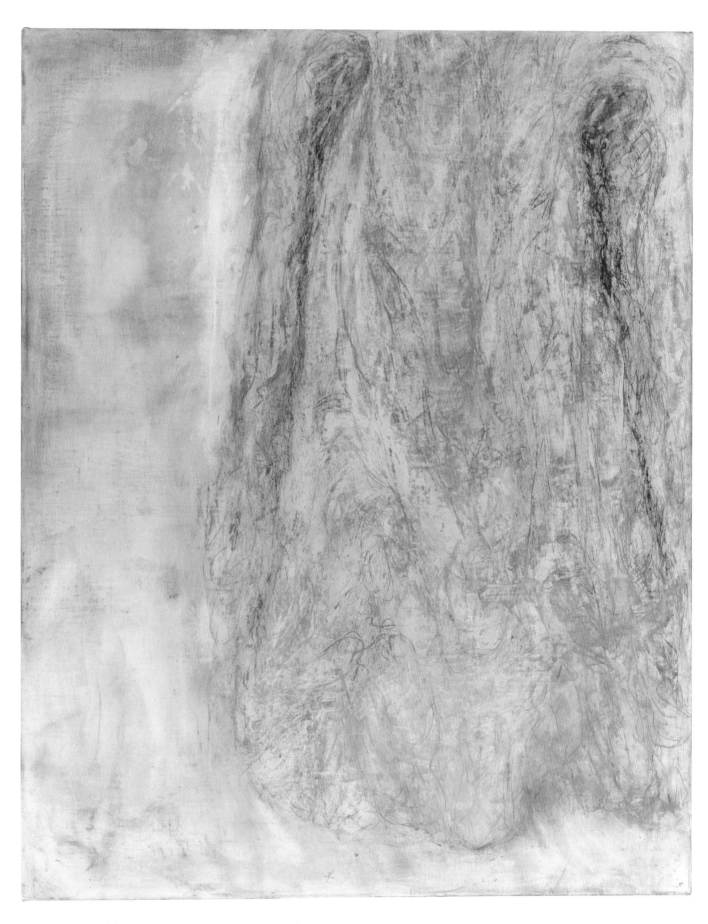

14. Double Stillness 2014–15 oil on linen diptych 50 x 86 in 127 x 218.4 cm

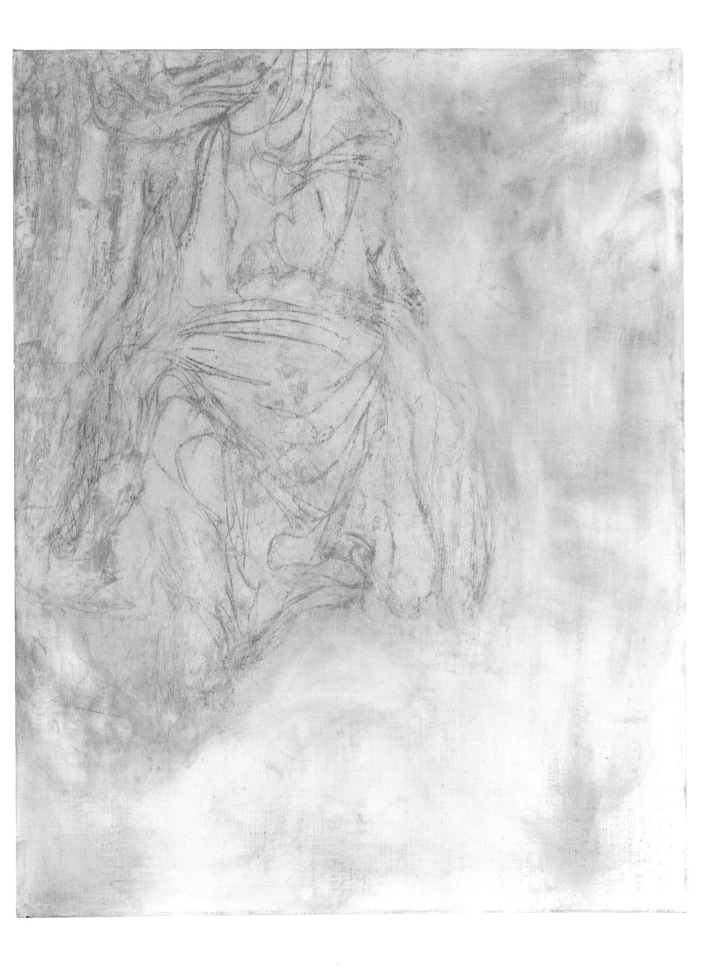

15. Message 2011–14 oil on linen 40 x 50 in 101.6 x 127 cm

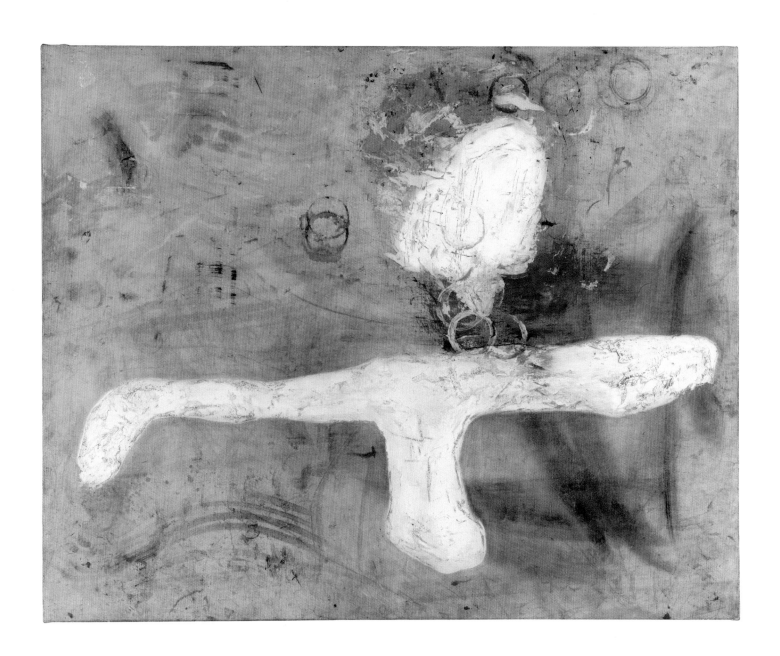

16. Luohan (Violet I) 2013–14 oil on linen 26 x 20 in 66 x 50.8 cm

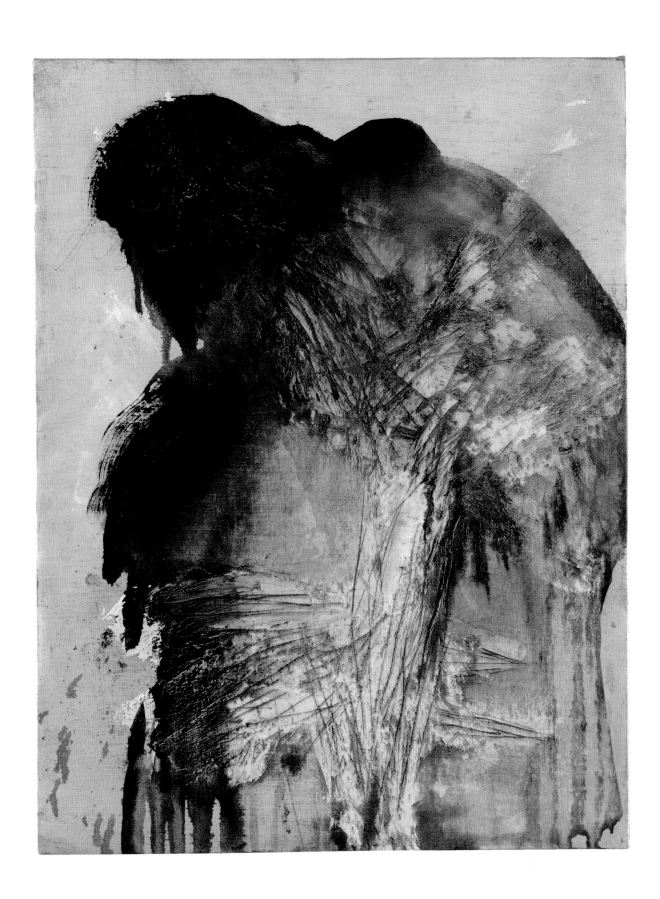

17. Luohan (Violet II) 2013–14 oil on linen 28 x 23 in 71.1 x 58.4 cm

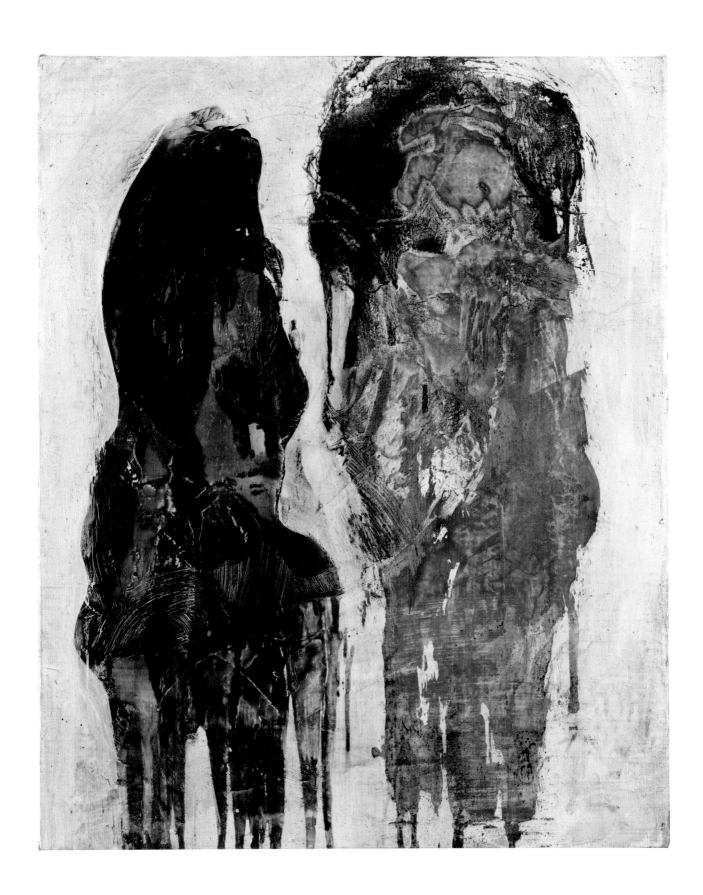

Dark Dragons

18. Dark Dragon Pool III (Old Master) 2014–15 oil on linen 28 x 23 in 71.1 x 58.4 cm

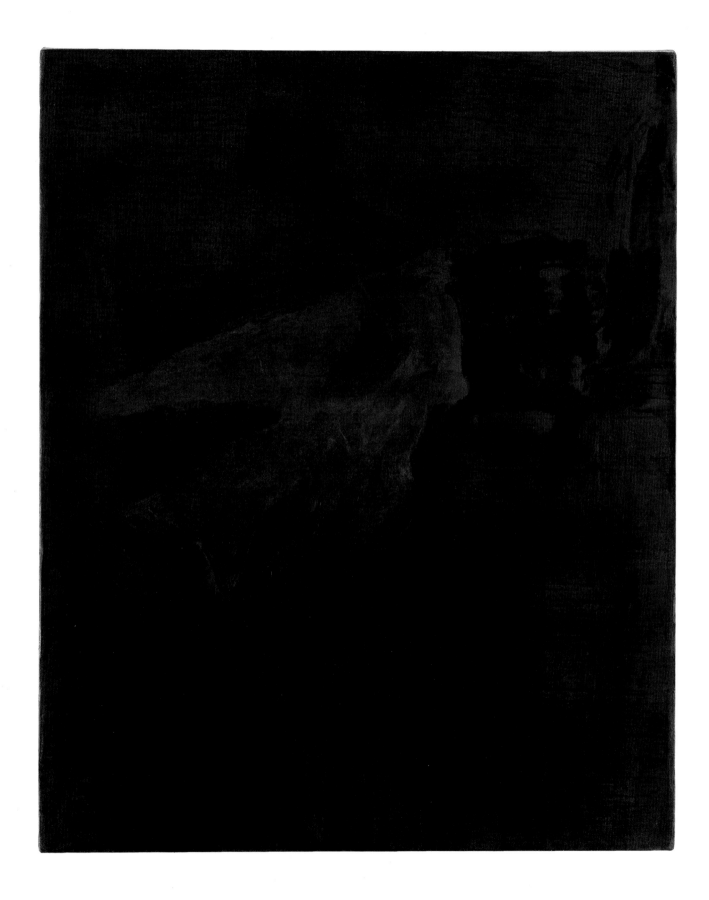

19. Dark Dragon Pool V 2014–15 oil on linen 20 x 26 in 50.8 x 66 cm

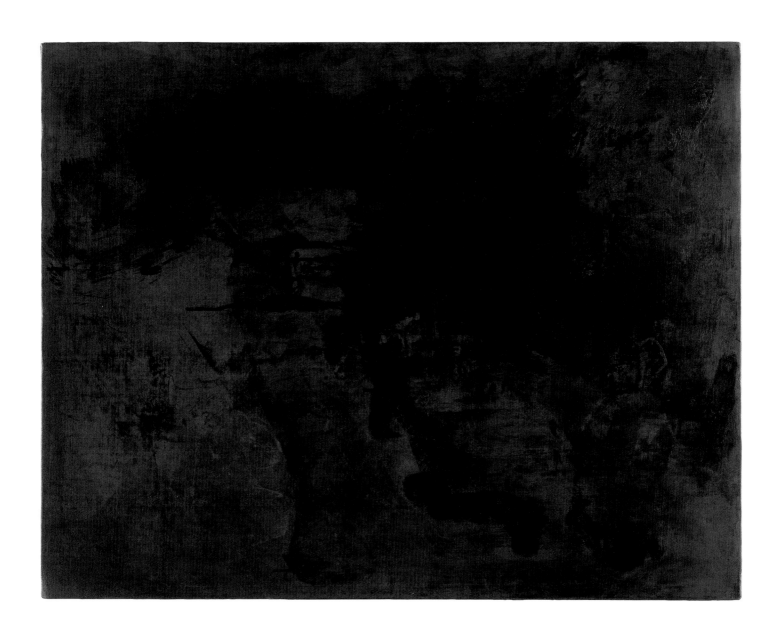

20. Dark Dragon Pool I 2014–15 oil on linen 39 x 32 in 99.1 x 81.3 cm

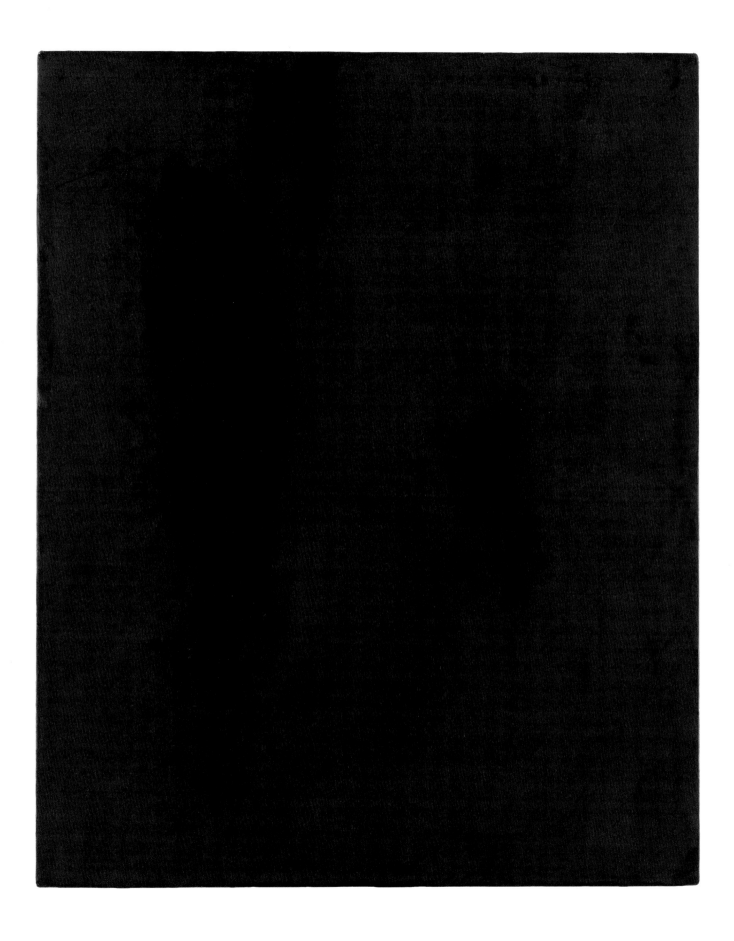

21. Dark Dragon Pool VII 2014–15 oil on linen 40 x 30 in 101.6 x 76.2 cm

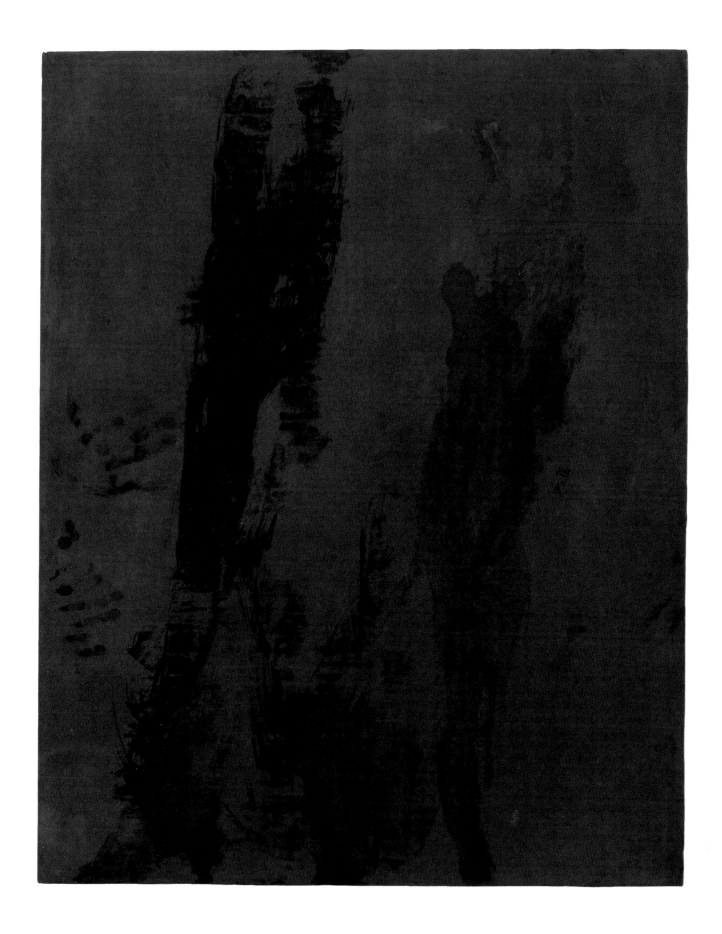

22. Now I Believe It Peak (Huangshan Mountain) 2014–15 oil on linen 48 x 38 in 121.9 x 96.5 cm

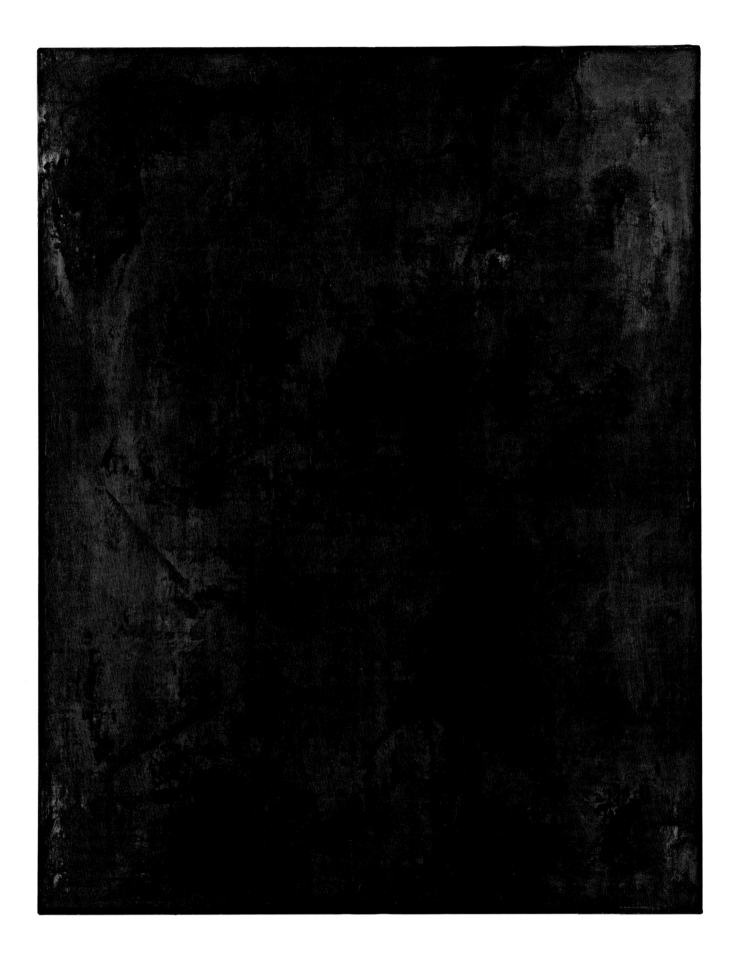

23. End of the Ordinary Realm (Huangshan Mountain) 2013–14 oil on linen 61 x 41 in 154.9 x 104.1 cm

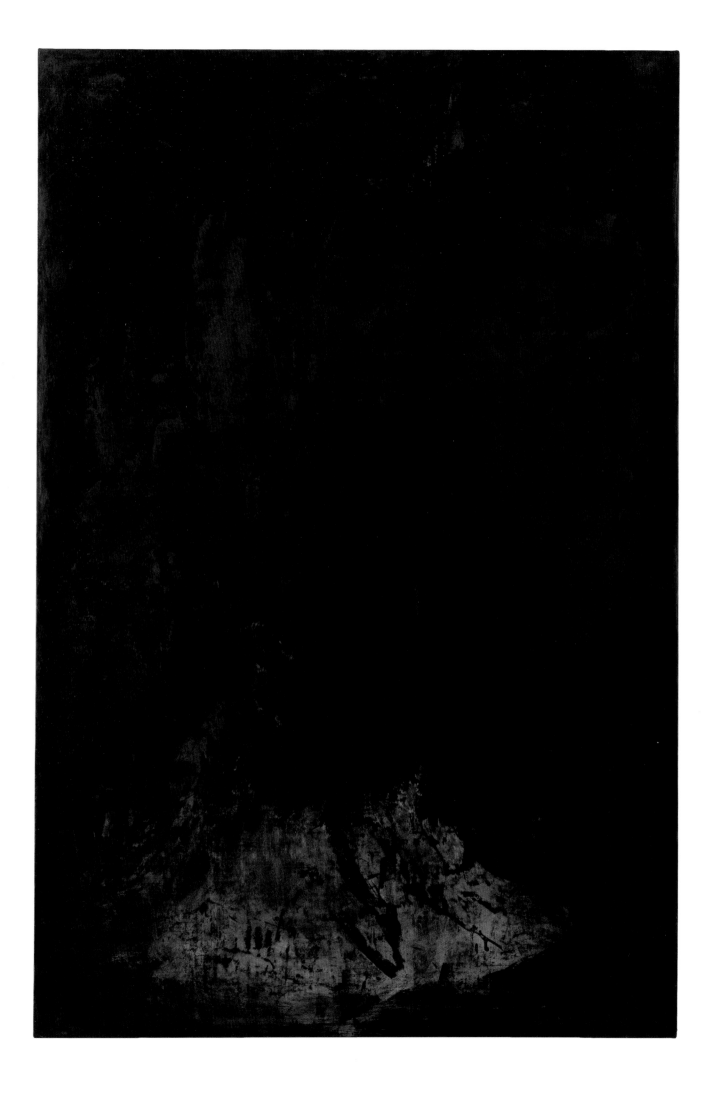

24. Thoughts Never Twisty (Confucius Quote) 2013–14 oil on linen triptych 53 1/2 x 124 in 135.9 x 315 cm

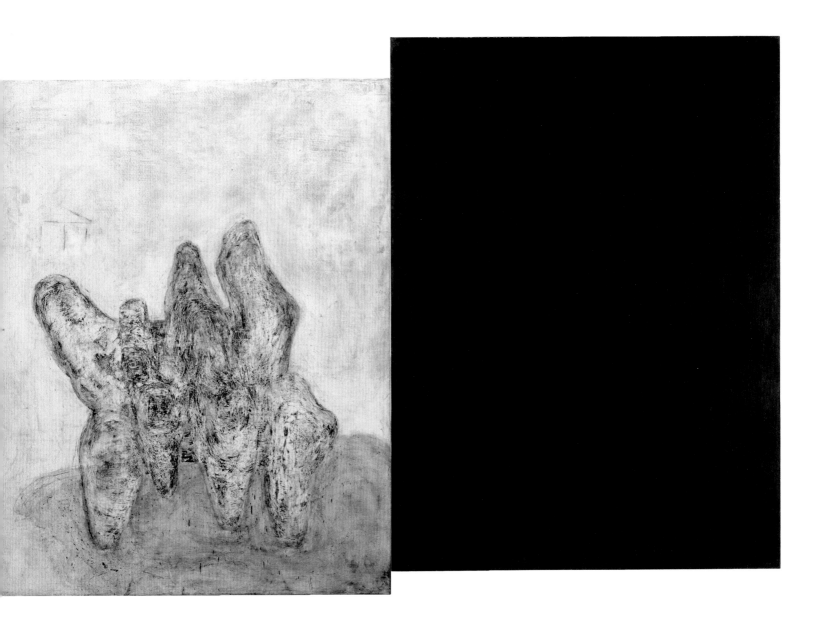

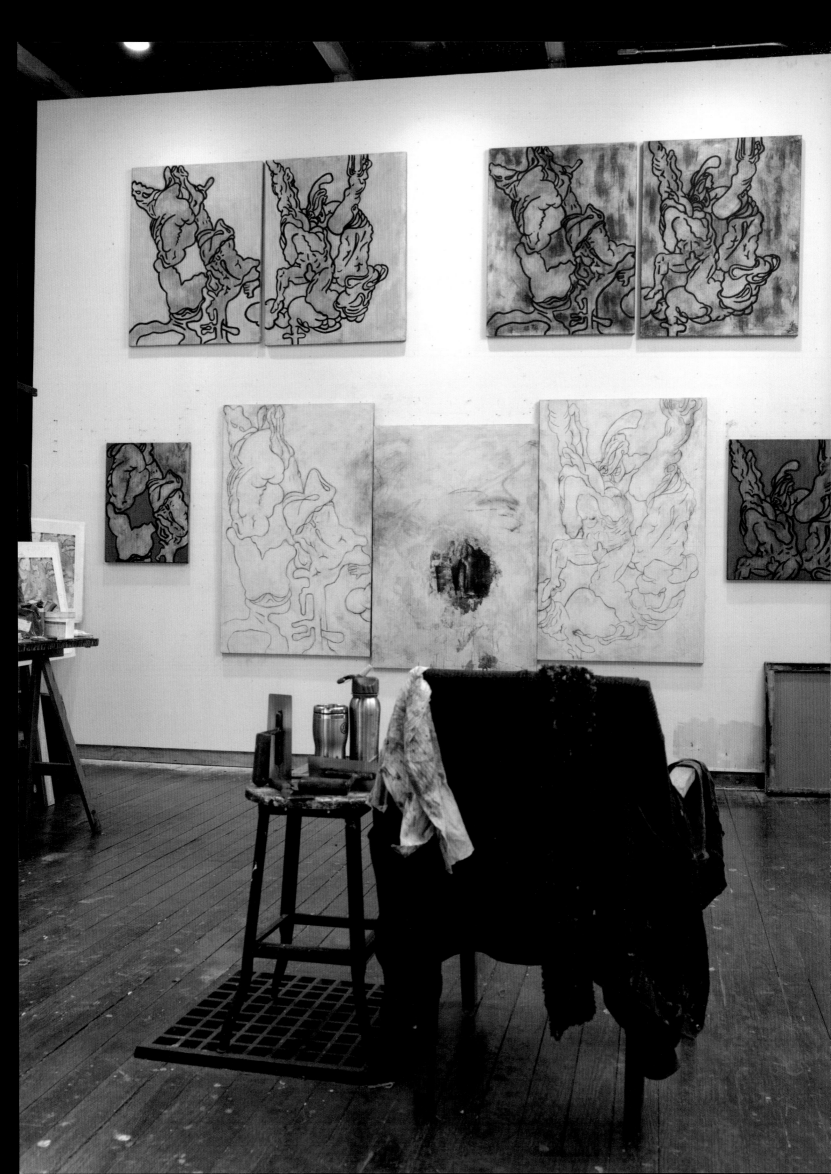

CHRONOLOGY

1945

William (Bill) Russell Jensen is born on November 26 in Minneapolis, Minnesota. His father abandons Bill and his mother when Bill is one day old.

1945–1950

Lives with grandparents on Lake Minnetonka, Minnesota; grandfather is a master cabinet maker.

1950

Donna Russell, Bill's mother, marries Reynald Jensen, who legally adopts him at age 5. With his mother and stepfather, he grows up in Turtle Lake, a rural community in Minnesota. Family lives in a small winterized lake cottage. Bill sleeps in a closet behind the fireplace. The closet has a window approximately the size of his paintings today. The window has a view of the lake.

During childhood, has many powerful psychic and aesthetic experiences with surrounding woods and lakes. Closest friend is a flexible flyer sled.

1957

With junior high school class, takes a field trip to the Minneapolis Art Institute, where he sees a room containing Chaim Soutine's hanging "beef" painting, a Max Beckmann triptych, and a medium-sized abstract Clifford Still painting. The work prompts an epiphany reminding him of his experiences around the lake. He claims his destiny is sealed at this moment: decides to become a painter, though not having any idea of what that means or how to do it.

1960

Begins a "weirdo" T-shirt business called "Tiny's Studios," making airbrushed T-shirts with images of monsters and hot rods, which he sells at car shows. Around this time, also begins working as a laborer with a construction company that builds bridges during the summer months.

1964–1968

Enrolls at the University of Minnesota, and studies painting with Peter Busa. Receives BFA in 1968. Becomes a carpenter on bridge crews for summer work.

1968–1970

Enters graduate program at the University of Minnesota, and continues studying with Peter Busa. Meets visiting artists Ed Dugmore, Michael Goldberg, Herman Cherry, and Tony Smith. Takes a class in Chinese art history from Professor Robert Poor; the course, focusing on paintings, is very influential, and sparked a lifelong passion for Chinese painting, poetry, and philosophy.

Sees a 1969 exhibition of minimalist art, *14 Sculptors: The Industrial Edge*, at the Dayton Gallery at the Walker Art Center; is mesmerized and terrified by a Ronald Bladen sculpture, *Cathedral Evening*, 1969.

Deeply involved in protests against the Vietnam War while a student; avoids the draft due to being "administratively unsuitable."

1970

Receives MFA.

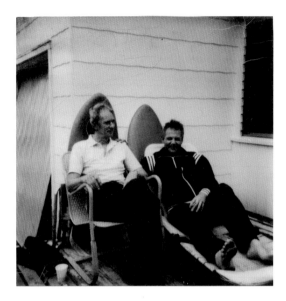

Ronald Bladen and Jensen in Westhampton, 1982

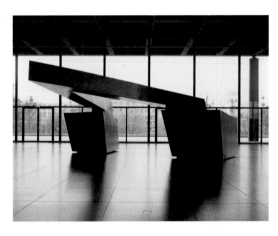

Ronald Bladen, *Cathedral Evening*, 1969

Teaches art outside Vienna, Austria, at a University of Minnesota summer program; leaves in protest over mistreatment of students. Takes motorcycle trip from Yugoslavia to Northern Scotland, with stops in Paris (where he visits the Louvre), London (where he goes to the National Gallery), and throughout Italy (including Rome and Florence).

Returns to Minneapolis, and builds bridges in the winter in order to save money for a move to New York City.

1971

Moves to New York City in June, bringing along ten drawings of spirals to make into paintings. Rents Herman Cherry's studio at 121 Mercer Street for the summer. Paints first large mixed-media spiral painting, *Smoked Oysters*.

Starts teaching Beckmann scholarship students at the Brooklyn Museum Art School; work is exhibited in a group faculty show at the museum. Does carpentry for extra income.

Sees five paintings by Albert Pinkham Ryder in the Brooklyn Museum's permanent collection and is blown away.

Moves to a studio at 489 Broome Street in Soho that fall. Builds walls for Fischbach Gallery that winter, which opens a downtown gallery located underneath his studio.

1972

In January, Bill is hired by Fischbach Gallery to install, with Ronald Bladen, Bladen's sculpture *Boomerang*, 1972; their meeting is the start of a

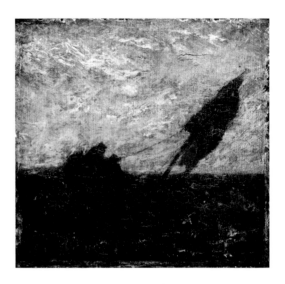

Albert Pinkham Ryder, *The Waste of Waters Is Their Field*, early 1880s

Last, 1973, oil on linen, 96 x 72 in, 245.1 x 195.6 cm

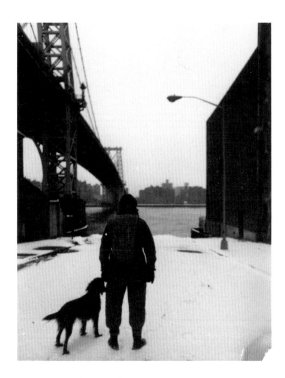

Jensen and Kief near Williamsburg Bridge, Brooklyn, 1976

Claude, 1979, oil on linen, 23 x 16 in, 58.4 x 40.6 cm

long and deep friendship. Will continue to help install Bladen's work until 1980.

1973
Starts to show with Fischbach Gallery; first exhibition is in March.

Paints *Last*, which is shown at Bykert Gallery. It is the last of his large-scale spiral paintings, as he develops an illness caused by the materials and is forced to change his practice.

Sees paintings by Myron Stout at Richard Bellamy's private gallery space.

1974
Moves studio to 90 Prince Street. Begins making shaped paintings out of found pieces of plywood covered with linen.

Included in a group faculty exhibition at the Brooklyn Museum.

1975
Quits teaching job at the Brooklyn Museum under protest for lack of women teachers. Shows for the last time at Fischbach Gallery, where he presents his recent shaped plywood-and-linen paintings, hanging them on walls he had built for the gallery in 1972.

Sees exhibitions of Marsden Hartley's paintings at Babcock Gallery and Washburn Gallery, New York, and an Arthur Dove retrospective at the Whitney Museum of American Art.

1976
Moves from Prince Street studio to 37 South 3rd Street; rents an entire building with sculptor

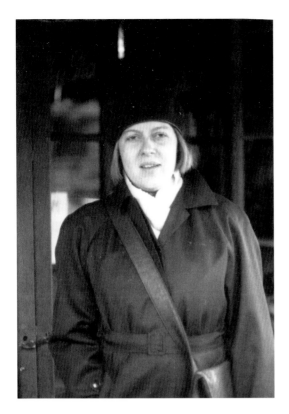

Margrit Lewczuk, South 3rd Street Studio, Brooklyn, 1986

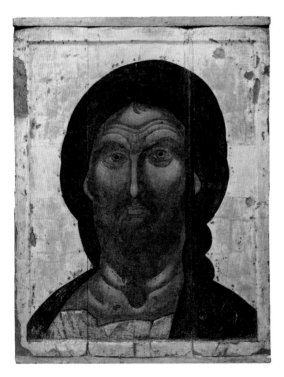

The Savior of the Fiery Eye, mid-fourteenth century

Bob Grosvenor in the then gritty Williamsburg section of Brooklyn. Living cheaply, works on the top floor making small-sized, rectangular paintings with nineteenth-century stretchers and Old Holland paint.

Retires from the art world, working reclusively in Williamsburg. For extra income, freelances as a mason. Self-imposed exile lasts until 1980.

In September, starts living with painter Margrit Lewczuk. Her studio and their home is located in Red Hook, at 36 Tiffany Place, in a loft building with no running water or heat. Bill bicycles between their home and his studio; collects firewood from abandoned lots and buildings.

Discovers the Mexican painters José Clemente Orozco and Frida Kahlo.

1978
With Margrit, moves to 250 South Street in Manhattan, which he calls "Shangri-La," at the foot of the Manhattan Bridge, where she has her studio. Several artists live and work in the building, including Jim Clark and Kiki Smith. Bill continues to commute to his studio on South 3rd Street in Williamsburg.

Installs Bladen's *Three Elements*, 1965, at an outdoor sculpture show in Houston, Texas. Visits the Rothko Chapel, where a Buddhist wedding is taking place. Revisits the chapel many times in the future.

1979
Visits an exhibition of Russian icon paintings from the Kremlin Museum, presented at the

Metropolitan Museum of Art. Returns to the show approximately 50 times, completely mesmerized by *The Savior of the Fiery Eye*, and the emotional depth achieved in the painting.

Begins the painting *Claude*, which is a result of his profound experience with the Russian icon paintings.

Receives an award from Creative Artists Public Service Program (CAPS). Meets Joan Washburn and after some deliberation, agrees to show with her gallery.

1980
Visits Marsden Hartley retrospective at the Whitney Museum of American Art. A large majority of the paintings are owned by the Walker Art Center and the University of Minnesota's Northrop Gallery, but had never been on view while Bill was in Minneapolis.

Trip to Block Island, Rhode Island. The surroundings inspire several paintings, including *Divers Ferry*, *Land's End*, and *Keepler*.

Moves with Margrit to 429 West 14th Street in the Meatpacking district of Manhattan. She has a studio in the space; he continues to commute to Williamsburg to paint.

Included in Barbara Rose's group exhibition, *American Painting: The Eighties – A Critical Interpretation*, at the American Center in Paris.

First solo show at Washburn Gallery, New York: *Recent Paintings and Drawings*. Hilton Kramer reviews the exhibition. Show includes *The Black Madonna*.

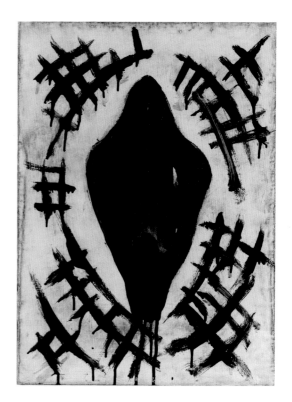

The Black Madonna, 1975–77, oil on linen, 23 x 17 in, 58.4 x 43.2 cm

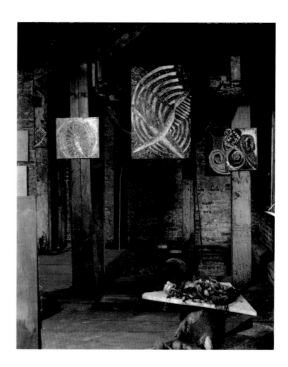

South 3rd Street Studio, 1981. Paintings from left to right: *Song of Stone*, *Divers Ferry*, *Lamb* (unfinished), *Sea Wall*

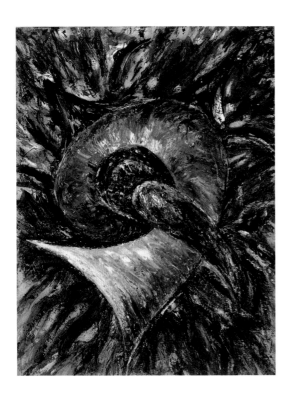

Memory of Closeness, 1981, oil on linen, 28 x 22 in, 71.1 x 55.9 cm

1981

South 3rd Street studio building is sold. Forced to vacate with other artists. Buys an abandoned building, also in Williamsburg, which he refers to as "The China Building" due to the hundreds of broken dishes inside. Fixes up building and uses it as his studio.

Participates in the *1981 Whitney Biennial* exhibition at the Whitney Museum of American Art.

Memory of Closeness, 1981, is acquired by the Metropolitan Museum of Art.

Recent Paintings and Drawings (1975–1981), a solo exhibition, opens at Washburn Gallery. Show includes *Memory of Closeness*.

1982

Included in a group show at Hamilton Gallery: *The Abstract Image.*

Travels to Washington, D.C., to see *Georges Braque: The Late Paintings, 1940–63* at the Phillips Collection. Braque had long been a big influence.

Solo exhibition at Washburn Gallery: *Gouaches on Paper.*

1983

Included in *Content in Abstraction: The Uses of Nature,* a group show at the High Art Museum, Atlanta, Georgia.

The Hayden Gallery, of the Massachusetts Institute of Technology, Cambridge, Massachusetts, presents *Affinities: Myron Stout, Bill Jensen, Brice Marden, Terry Winters.* A very memorable show to Bill.

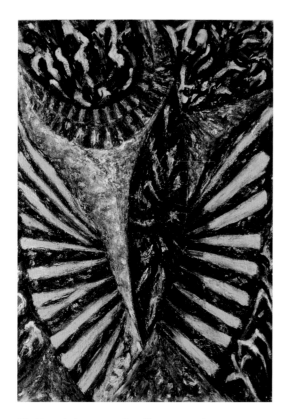

The Vanquished, 1982–83, oil on linen, 25 x 36 in, 63.5 x 91.4 cm

At Skowhegan working on *Deadhead*, 1986

Included in *Tendencias en Nueve York*, a travelling group exhibition presented at the Palacio de Velázquez, Madrid, and the Fundació Joan Miró, Barcelona, Spain.

Invited by Bill Goldston of Universal Limited Art Editions, the renowned print publisher and studio, to make etchings. Had met Goldston in graduate school at the University of Minnesota, and the two kept in touch. Despite initial trepidation, makes a first visit to the Long Island studio and is immediately hooked, later stating, "Etching is a very severe way to draw." Continues to go to ULAE at least once or twice a month for the next several years. Printmaking becomes integral to his artistic practice, and begins to affect his other work. He does not distinguish hierarchies between mediums: his paintings, drawings, gouaches, and prints always happen simultaneously.

1984
Riva Castleman, head curator of prints at the Museum of Modern Art, New York, sees an impressive stack of proofs of Bill's etchings at ULAE; she initiates the print show Bill will have at the museum in 1986.

A solo exhibition, *Recent Paintings and Drawings*, is presented at Washburn Gallery. Show includes *The Vanquished*.

Participates in a four-day visiting artist's workshop at Skowhegan School of Painting and Sculpture, Skowhegan, Maine, invited and encouraged by Ronald Bladen.

Shows seventeen paintings spanning eight years (1973–1981) in the exhibition *Five Painters*

in New York: Brad Davis, Bill Jensen, Elizabeth Murray, Gary Stephan, John Torreano, at the Whitney Museum of American Art.

Participates in *The Meditative Surface* at the Renaissance Society at the University of Chicago, and *An International Survey of Recent Painting and Sculpture* at the Museum of Modern Art, New York, among other national exhibitions.

1985
Included in the *1985 Carnegie International* at the Museum of Art, Carnegie Institute, Pittsburgh, Pennsylvania.

Included in *Painting as Landscape: Views of American Modernism, 1920–1984* at the Parrish Art Museum, Southampton, New York; *Drawing Acquisitions 1981–1985* at the Whitney Museum of American Art; and *'Scapes* at the University Art Museum, University of California, Santa Barbara, California, in addition to several group gallery exhibitions.

Receives artist's fellowship from the National Endowment for the Arts.

1986
Spends summer months teaching at the Skowhegan School of Painting and Sculpture, Maine. Primordial woods surrounding his studio influence a radical change in his work; painting intensively outdoors, he attempts to convey nature as it is when "people are not around," unburdened by human's mannerist interpretation of the environment. Makes three important paintings—*Moat, Sled,* and *Deadhead*—which signal this new approach.

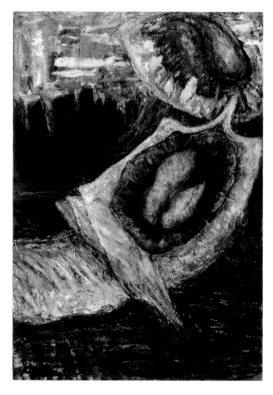

Sled, 1986, oil on linen, 39 1/4 x 28 1/2 in, 99.7 x 72.4 cm

Later, studying Taoist philosophy, he comes across the phrase "occurrence appearing of itself," which connects deeply to what he was attempting to achieve at Skowhegan and again upon his return to New York, when he paints *Riddle*.

The Museum of Modern Art, New York, presents *Bill Jensen: First Etchings*, a selection of prints curated by Deborah Wye.

Included in *The Spiritual in Art: Abstract Painting, 1890–1985*, which opened at the Los Angeles County Museum of Art, California, and travelled to the Museum of Contemporary Art, Chicago, and Haags Gemeentemuseum, The Hague, The Netherlands.

Also included in *Major Acquisitions Since 1980*, at the Whitney Museum of American Art.

A solo exhibition, *Recent Paintings and Drawings*, opens at Washburn Gallery.

1987
Son, Russell Sled Lewczuk-Jensen, is born in New York City. Paints *Month of February*.

Drawings included in a survey exhibition, *Twentieth Century Drawing* from the Whitney Museum of American Art, which opens at the National Gallery of Art, Washington, D.C., and travels to the Cleveland Museum of Art, Cleveland, Ohio; the Achenbach Foundation for Graphic Arts at the California Palace of the Legion of Honor, San Francisco, California; the Arkansas Art Center, Littlerock, Arkansas; and the Museum of American Art, Fairfield County, Stamford, Connecticut. Also included in *The*

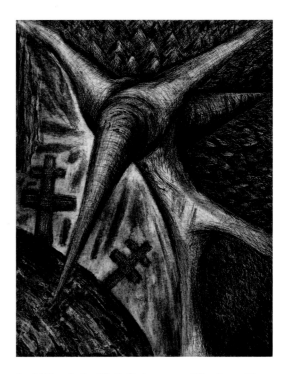

Daniel (from the Portfolio Endless), 1985, portfolio of 11 etchings on handmade John Koller paper, 15 1/2 x 20 in, 39.37 x 50.8 cm

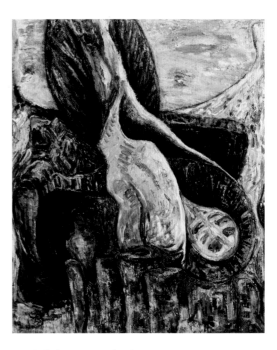

Month of February, 1987, oil on linen, 35 1/8 x 30 1/4 in, 89.2 x 76.8 cm

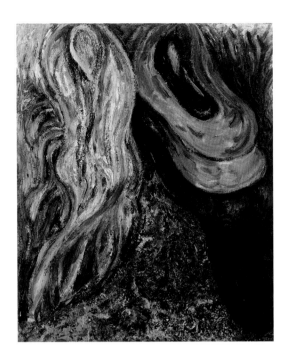

Old Man's Ass (Deer Isle, Maine),1987, oil on linen,
30 1/4 x 25 1/8 in, 76.8 x 63.8 cm

Fortieth Biennial Exhibition of Contemporary American Painting at the Corcoran Gallery of Art, Washington, D.C.

Survey exhibition at the Phillips Collection, Washington, D.C.; travels to the Lannan Museum, Lake Worth, Florida.

Solo exhibition at Washburn Gallery: *Recent Gouaches and Watercolors on Paper.*

Travels to Stockholm with Margrit and Russell for Margrit's exhibition at the Bjorn Wetterling Gallery; they see a Munch exhibition, *Munch and his Contemporaries*, at the Moderna Museet in Stockholm. Family travels by boat train to Paris, and visits the Louvre. The museum's collection of Brueghel paintings are particularly influential.

1988
In February, Ronald Bladen dies of cancer. Paints *Winter*, and *Givers & Takers*.

Solo exhibitions at the Lannan Museum, Lake Worth, Florida, and at Washburn Gallery.

With Margrit and Russell, spends the fall months at the American Academy in Rome. Family flies into Frankfurt and travels extensively through Europe on their way to the Academy. While there, they make trips to Venice, Florence, Assisi, Siena, Bologna, and other sites in Umbria, Tuscany and Abruzzo. The trip is life-changing.

Discovers Italian turpentine with Margrit, called *Essenza di Trementina*, which thins paint substantially while still retaining powerful color. Had previously worked with oil paint straight out of the tube; paint was applied and scraped

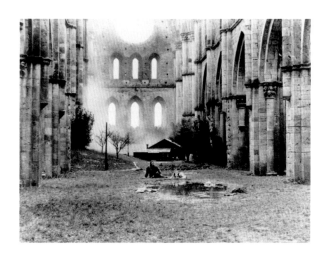

Andrei Tarkovsky, *Nostalghia*, 1983 (still). Scene filmed at San Galgano, a church close to Jensen's summer residence in Siena.

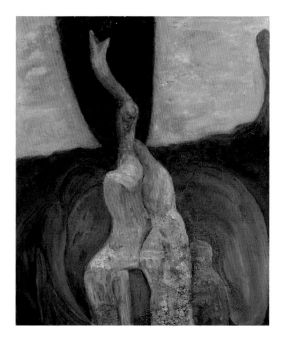

Babar, 1988, oil on linen, 39 1/4 x 33 1/4 in, 99.7 x 84.5 cm

down, and texture was built up through scraping residue. After adopting the turpentine, paintings were "washed" or wiped down between layers, resulting in a thinner but as intense layer of paint. Also begins adding soft wax to paint, influenced by the dry, chalky color of Italian frescoes. While in Italy, paints *Babar* and *Antica*.

Included in a group show, *The Abstract Impulse,* at Davis/McClain Gallery in Houston, Texas, and in *Past/Present* at Washburn Gallery.

Participates in *Sightings: Drawing with Color* at the Institute of North American Studies, Barcelona, Spain, which travels throughout 1989 to Casa Revilla, Valladolid, Spain; Calouste Gulbenkian Foundation, Lisbon, Portugal; Pratt Manhattan Gallery, New York; and the Rubelle and Norman Schafler Gallery at Pratt Institute, Brooklyn, New York.

1989
In January, returns to New York from the American Academy via Frankfurt.

Solo show, *Recent Watercolors*, at Washburn Gallery.

Included in *A Debate on Construction: The Persistence of Painting* at the Bertha and Karl Leubsdorf Art Gallery, Hunter College, New York.

Family returns to Italy for the summer and stays at Al Held's place in Camarata, Umbria, near Perugia and Assisi. Paints *Greek Gardens* and others. Spends time studying Giotto in the Basilica of Saint Francis of Assisi, and makes several small gouache drawings of Giotto's frescoes.

They travel to Madrid, visiting the Prado Museum and seeing Goya's Black Paintings.

1990

Washburn Gallery presents *Bill Jensen: Etchings*.

Again, family returns to Italy for the summer, renting a house in Umbertide. While there, visits a friend at an estate near Siena and falls in love with the area. During this trip and all subsequent visits, they consistently make treks to Arezzo, Sansepolcro, and Monterchi (revisiting works by Piero della Francesca and Rosso Fiorentino), Florence and environs (Beato Angelico at San Marco; and Masaccio at Brancacci Chapel and at San Pietro a Cascia, Museo Masaccio), and Siena (Duccio and works by the Lorenzetti brothers).

1991

Solo shows at Margo Leavin Gallery, Los Angeles, California, and Grob Gallery, London, which presents *Bill Jensen: Paintings*.

Solo show at Washburn Gallery. Show includes *Givers & Takers*.

Also included in group exhibitions at John Berggruen Gallery, San Francisco, California, and André Emmerich Gallery, New York: *Abstract Painting in the 90's*.

In summer, the family rents a house—Palazzo Torre, an eleventh-century tower—in the same estate outside of Siena. Will return every summer for the following 10 years.

Discovers Russian filmmaker Andrei Tarkovsky's 1986 book *Sculpting in Time*, igniting a lifelong passion. Deeply moved by Tarkovsky's films and philosophy, Bill usually has his movies playing in the background while he paints (also plays films by Ingmar Bergman and Akira Kurosawa).

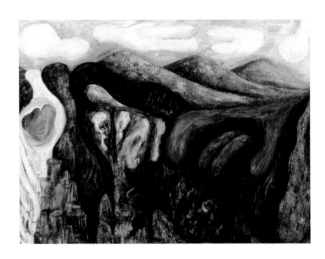

Givers & Takers, 1987–88, oil on linen, 35 1/8 x 47 3/16 in, 89.2 x 119.9 cm

1992

Participates in the *44th Annual Purchase Exhibition* at the American Academy of Arts and Letters, New York. Also included in *In the Spirit of Landscape* at Nielsen Galleries, Boston, Massachusetts, and *Abstraction Per Se* at André Emmerich Gallery, New York, which travels to the Rubelle and Norman Schafler Gallery at Pratt Institute, Brooklyn, New York, in 1993.

Solo show, *Works on Paper*, at Washburn Gallery.

1993

Participates in a group exhibition, *Intimate Universe*, which shows at Michael Walls Gallery, New York, and Nina Freudenheim Gallery, Buffalo, New York. Also included in *Painting*, an exhibition at Texas Gallery, Houston, Texas.

First solo show at Mary Boone Gallery, New York.

In December, participates in a panel discussion at the Robert Ryman retrospective at the Museum of Modern Art, New York, moderated by Robert Storr, and presents a paper titled "Feeling in the Air" about Ryman's work.

1994

Included in the *American Academy Invitational Exhibition of Painting and Sculpture* at the American Academy of Arts and Letters, New York. Also shows in *Isn't It Romantic?* at On Crosby Street, New York.

Bill Jensen: Drawings 1993–1994 opens at Washburn Gallery. Additional solo exhibition at Nielsen Gallery, Boston, Massachusetts.

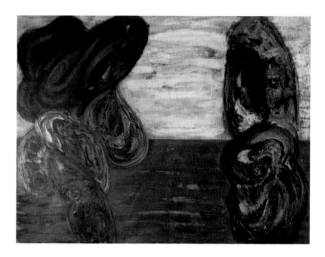

For George (George Trakl), 1993, oil on linen, 30 x 40 in, 76.2 x 101.6 cm

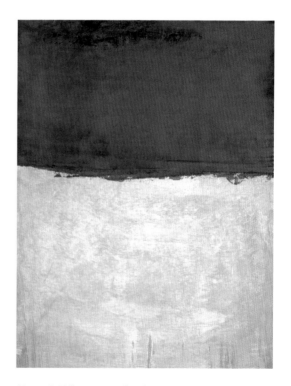

Heaven & Hell, 1997–98, oil on linen, 40 x 30 in, 101.6 x 76.2 cm

1995
Solo show at Mary Boone Gallery, and at Patricia Faure Gallery, Santa Monica, California. Travels to Los Angeles for the installation. Show includes *Stalker*.

1996
Included in *The Legacy of American Modernism* at Kohn Turner Gallery, Los Angeles, California, and in *Essence – Twenty Abstract Painters* at Radix Gallery, New York.

Washburn Gallery presents *Recent Drawings*.

During the winter, the family travels to Copenhagen.

1997
On September 15, buys the building adjacent to his "China Building" studio in Williamsburg. The new purchase is a rundown factory that had been used for the glazing of dishes. Begins renovating the space.

Participates in *After the Fall: Aspects of Abstract Painting since 1970* at the Newhouse Center for Contemporary Art, Snug Harbor Cultural Center, Staten Island, New York, as well as *Concept / Image / Object: Recent Gifts from the Lannan Foundation* at the Art Institute of Chicago, Illinois, and the *American Academy of Arts and Letters Invitational Exhibition of Painting and Sculpture*, in which he receives the Purchase Award.

Included in *Landscape as Abstraction* at James Graham & Sons, New York, and in *Intimate Universe (Revisited)*, which shows at Robert Steele Gallery, New York, and James Howe Fine Arts Gallery, Kean University, Union, New Jersey.

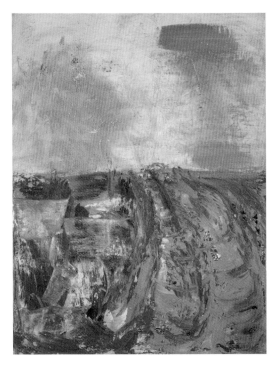

Stalker, 1993–94, oil on linen, 39 x 30 in, 99.1 x 76.2 cm

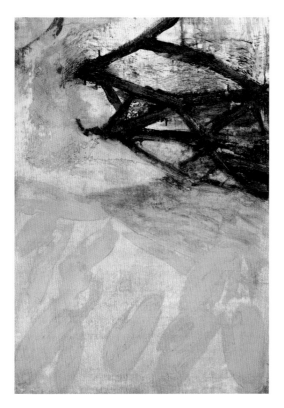

A Few Small Nips, 1995–98, oil on linen, 39 x 27 in, 99.1 x 68.6 cm

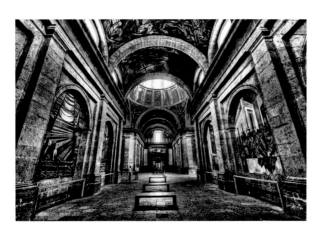

José Clemente Orozco, Hospicio Cabañas, 1936–39

1998
Show at Mary Boone Gallery. Show includes *A Few Small Nips*.

Shows in several group exhibitions, including *Original Scale*, Apex Art, New York; *Small Paintings*, Cheim & Read, New York; and *Bill Jensen, Barry Le Va, Pat Steir: New Work* at Danese, New York.

1999
On November 24, a huge fire engulfs Margrit's studio, and the family's home, which has remained on 14th Street. Fire destroys twenty-five years' worth of her work, as well as all their belongings, including their art collection. In the aftermath, they move her studio and their home to the buildings in Williamsburg.

Family travels to Mexico City, where they see works by Frida Kahlo, Diego Rivera, and José Clemente Orozco. In Guadalajara, they visit all of Orozco's murals, including the cycle of 57 frescoes at the Hospicio Cabañas (Instituto Cultural Cabañas), with its famous *El Hombre de Fuego (The Man of Fire)*. Claims that the murals are as good as anything in the Renaissance.

Bill Jensen: Paintings & Works on Paper opens at the Joseloff Gallery, University of Hartford, Connecticut.

2000
Danese Gallery, New York, presents *Bill Jensen: Drawing in a Zig Zag Way*. The title of the exhibition is inspired by contemporary Chinese Poetry: like the Beat Poets of the 1950s, China's new generation of poets are called the *fe-fe* ("no-no"), and against stylistic poetic tropes and

tradition, they write poetry in a "zig-zag" way.

During August, family stays at Kamp Kippy (Acadia Summer Arts Program), an artist's fellowship program in Mount Desert Island, Maine, established by Marion "Kippy" Stroud.

In November, travels to Japan with Margrit and Russell as a visiting lecturer at the University of Nagoya. They stay in Japan for almost a month, and visit Kyoto, Nara, and several temples and shrines, including the Ise Grand Shrine, the moss garden at Saihō-ji, and the rock gardens in Ryōanji, Kyoto. An exhibition of paintings by the eighteenth-century, mid-Edo Period artist Itō Jakuchū at the Kyoto National Museum is particularly significant. The trip impacts the whole family.

2001
Solo exhibition at Mary Boone Gallery. Show includes *Kuroscuro I*.

Spends time at a residency at the Vermont Studio Center, and then returns, as usual, to Italy for the summer months.

On September 10, gives a lecture as a visiting artist at Louisiana State University about José Clemente Orozco and American involvement in the Mexican Revolution.

In October, the family travels to Düsseldorf, Germany, for an exhibition at Felix Ringel Galerie: *Bill Jensen: Images of a Floating World*. While there, they reside at the beautiful Museum Insel Hombroich, a Barnes-like museum and artist-in-residency space outside of Düsseldorf.

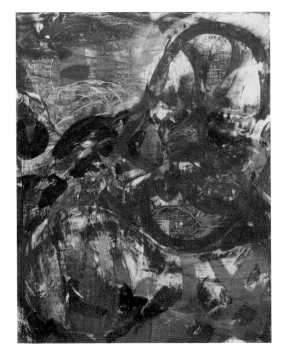

Smelt, 2004–06, oil on linen, 40 x 32 in, 101.6 x 81.3 cm

Ape Herd III, 2001–03, oil on linen, 46 x 38 in, 116.8 x 96.5 cm

In December, returns to Mexico. The family visits the ruins and temples at Tulum, Chichen Itza, and Coba.

Bill Jensen: Works on Paper is presented at Bobbie Greenfield Gallery, Los Angeles, California.

2002
Bill Jensen: Works on Paper opens at Danese Gallery.

Included in *Northern Light*, a group show at Danese Gallery, and *Boundless/Silence: States of Infinity* at DC Moore Gallery, New York.

Returns to Italy in the summer, and starts renting the sixteenth-century Palazzo Loggia, outside of Siena in the same estate.

2003
Asked to judge an alumni show at the New York Studio School. With Margrit, begins teaching a painting atelier at the school soon after.

Participates in two group exhibitions: *Black/White* at Danese Gallery, and *Graphic Masters: Highlights from the Smithsonian American Art Museum* at the Hecksher Museum of Art, Huntington, New York.

Mary Boone Gallery presents *Bill Jensen: New Paintings*. Show includes *Ape Herd III*.

Solo exhibition at Texas Gallery, Houston, Texas. Visits Rothko Chapel.

2004
In March, Danese Gallery presents *Bill Jensen: Duo Duo and Drunken Brush Drawings*. "Duo

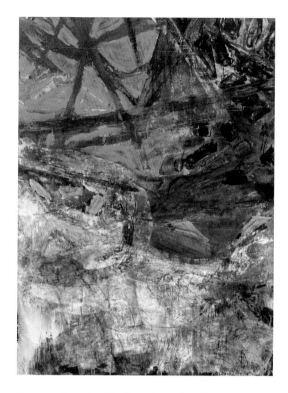

Occurrence Appearing of Itself, 2006–09, oil on linen, 54 x 40 in, 137.2 x 101.6 cm

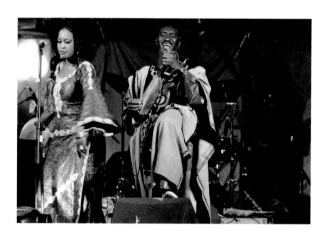

Bassekou Kouyaté and Ami Sacko, Festival au Désert 2009, Essakane, Mali

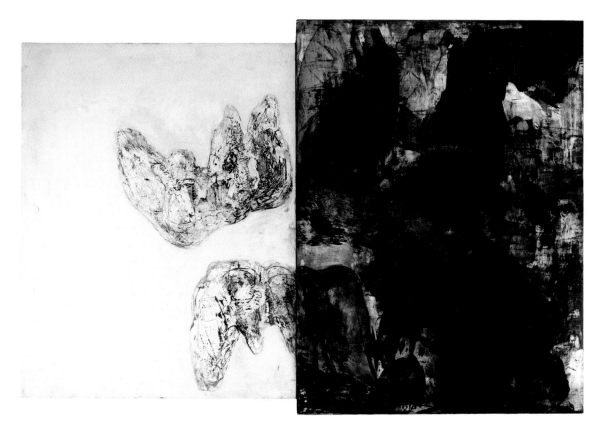

Passions According to Andrei (Rublev/Tarkovsky), 2010–11, oil on linen, diptych, 53 1/2 x 78 1/2 in, 135.9 x 199.4 cm

Duo" is a Chinese Fe-Fe poet and "drunken brush" comes from a Chinese poem.

Participates in a group exhibition, *The Self-Reliant Spirit* at Nielsen Gallery, Boston, Massachusetts. Also included in a travelling exhibition, *Graphic Masters: Highlights from the Smithsonian American Art Museum*, which travels from the Palmer Museum of Art, Pennsylvania State University, to the Hunter Museum of Art, Chattanooga, Tennessee; the Frances Lehman Loeb Art Center, Poughkeepsie, New York; and the Plains Art Museum, Fargo, North Dakota.

2005
Spends summer months in Italy.

2006
Texas Gallery, Houston, presents *Bill Jensen*.

Included in *The New Landscape/The New Still*

Life: Soutine and Modern Art at Cheim & Read, New York. Writes an essay on Soutine for the accompanying catalogue.

Participates in *Barely Minimal* at the Nielsen Gallery, Boston, Massachusetts, and in *In Stillness* at the Butler Institute of American Art, Howland Township, Ohio.

2007
First solo exhibition at Cheim & Read, New York.

Travels to Tunisia for Margrit's show in Carthage. Visits National Bardo Museum to see mosaics. Takes bus to visit Kairouan, where Klee and Kandinsky reportedly had epiphanies.

Solo show at ACME, Los Angeles, California.

Summer at Palazzo Loggia in Italy.

Hushed Mountains V, 2015–16, oil on linen,
40 x 32 in, 101.6 x 81.3 cm

Oracle Bones II, 2009–10, oil on linen, 32 x 27 in, 81.3 x 68.6 cm

Bill Jensen & Lucio Fontana is presented at Il Cerchio, Galleria d'Arte Moderna, Milan, Italy.

Participates in *Audacity in Art: Selected Work from Central Florida Collections*, a group exhibition at the Orlando Museum of Art, Orlando, Florida.

2008
Danese Gallery opens *Notes from the Loggia*, a solo exhibition.

Included in *Significant Form, The Persistence of Abstraction*, a group show at the Pushkin State Museum of Fine Arts, Moscow, Russia.

Party @ Phong's House, curated by the painter Chris Martin, opens at Galeria Janet Kurnatowski, Brooklyn, New York.

Galeria II, Cerchio, Milan, Italy, presents *American & British Artists*.

In October, travels to Marfa, Texas, with Margrit. In Marfa's local bookstore, discovers anthologies of Chinese poetry translated by David Hinton, and is struck by the clarity of Hinton's introductions and seemingly effortless translations. Hinton will later write a catalogue essay for Bill's 2010 exhibition at Cheim & Read; the two become close friends.

2009
Included in *Prescriptions* at ACME, Los Angeles, California; *After Image* at Paula Cooper Gallery, New York; and *Abstractions by Gallery Artists* at Cheim & Read.

Spends the summer at Palazzo Loggia, in Italy. Solo exhibition at Texas Gallery, Houston.

2010

In January, travels to Africa, spending three weeks in Bamako, Mali, and attending a music festival, Festival au Désert, near Timbuktu. Reminded of Matisse in Flanders by the reddish hue of the Saharan sand and its contrast with the bright, beautiful fabric worn by local people. Every street corner in Bamako reminds them of a Robert Rauschenberg combine; the remarkable visual overload, and the mixtures of colors, textures, shapes, along with the local people, result in a powerful and deeply spiritual experience.

Solo exhibition at Nina Freudenheim Gallery, Buffalo, New York.

Cheim & Read presents *Bill Jensen: New Work*. Show includes *Occurrence Appearing of Itself*.

Graphic Masters III, a group exhibition, is presented at the Smithsonian Museum of Art, Washington, D.C. Participates as well in *Carl Plansky and Friends* at the Sam and Adele Golden Gallery, New Berlin, New York.

2011

Included in the group exhibition *To the Venetians* at the Rhode Island School of Design, Providence, Rhode Island.

Stays in Palazzo Loggia, Italy, for the summer months.

Included in *ABSTRACTION*, a show at the Albert Merola Gallery in Provincetown, Massachusetts.

2012

Cheim & Read presents *Bill Jensen*, an exhibition of new, multi-paneled paintings based on compositions by the Russian icon painter Andrei Rublev. Show includes *Passions According to Andrei (Rublev/Tarkovsky)*.

In January, travels to Istanbul, Turkey, with Margrit. Thinks the Hagia Sophia is the greatest architectural experience and is very moved by the Ottoman architecture of Mimar Sinan and his work for Sultan Süleyman. Also visits mosaics and frescoes at the early Christian church and monastery complex of Chora (now a museum).

In February, travels to Kiev, Ukraine. The American Embassy buys three of Margrit's paintings. Spends two weeks in the city; visits Kyiv Pechersk Lavra and its renowned catacombs.

Included in *Dark Matters*, a group exhibition at Steven Harvey Fine Art Projects, New York.

Solo exhibitions at ACME, Los Angeles, California (*Bill Jensen: Recent Works*), and Hiram Butler Gallery, Houston, Texas (*Bill Jensen: Prints 2001–2012*).

Spends several weeks of the summer in a house near a farm that son Russell runs in Vermont, and sets up a studio there. Begins to intensely study Michelangelo's *Last Judgment* at the Sistine Chapel, and in particular a section right of center, *The Struggle of Good and Evil*, trying to focus on the visceral aspects of the painting and the underlying paganism of the imagery, not the corporeality of the forms Michelangelo is so famous for. Starts first drawings for the *Transgressions* series.

2013

Steps down from his position as atelier head at New York Studio School and becomes the "Painting Technician."

Bill Jensen: Floating World is presented at Yoshii Gallery, New York. Show includes *Oracle Bones II*.

Featured in *Reinventing Abstraction: New York Painting in the 1980s*, a group show curated by Raphael Rubinstein at Cheim & Read.

Spends the summer months in Italy, departing in May, and returning late August.

Included in *Come Together: Surviving Sandy, Year I*, curated by Phong Bui, at Industry City, Brooklyn, New York.

2014

In June, visits the great *Hilma af Klint* exhibition at the Louisiana Museum in Denmark.

Son Russell buys land in Vermont, and begins setting up an organic, sustainable farm with an Italian family from Siena.

Becomes a member of the American Academy of Arts and Letters, New York. Included in *Exhibition of Work by Newly Elected Members and Recipients of Honors and Awards*.

Participates in *Bloodflames Revisited*, a group show curated by Phong Bui at Paul Kasmin Gallery, and *Art in the Making*, at Freedman Art, New York.

2015

Included in several group exhibitions including, *Intimacy in Discourse: Reasonable and Unreasonable*

Sized Paintings, curated by Phong Bui, at Mana Contemporary, Jersey City, New Jersey.

Cheim & Read presents *Bill Jensen: Transgressions*. Begun in 2012, the *Transgressions* series, presented in the first room of the gallery, includes multi-paneled compositions based on Michelangelo's *The Last Judgment*. In the second room, additional works continue the *Book of Songs* series, and include *Book of Ch'u*, the triptych *Loom of Origins*, and *Double Sorrow +1 (Grey Scale)*. In the third room, *Stillness* and *Double Stillness* are featured, and in the fourth room, several "dark paintings" including *Thoughts Never Twisty* and the *Dark Dragon Pool* series [*Now I Believe It Peak (Huangshan Mountain)*, and *End of the Ordinary Realm (Huangshan Mountain)*] are shown.

Travels to Italy in the summer months, visiting Rome, Naples, and the Amalfi coast.

In September, son Russell and Elizabeth Roma are married on their land in Vermont.

In November, celebrates his 70th birthday on Thanksgiving Day, and finalizes the legal paperwork for the Bill Jensen/Margrit Lewczuk Foundation, an artists' residency to be set up in the future.

2017

Presentation of "black paintings" at ADAA: *The Art Show*.

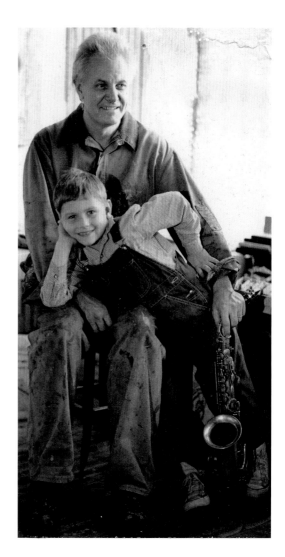

Jensen and Russell with Ronald Bladen's saxophone,
Metropolitan Avenue studio, 1993

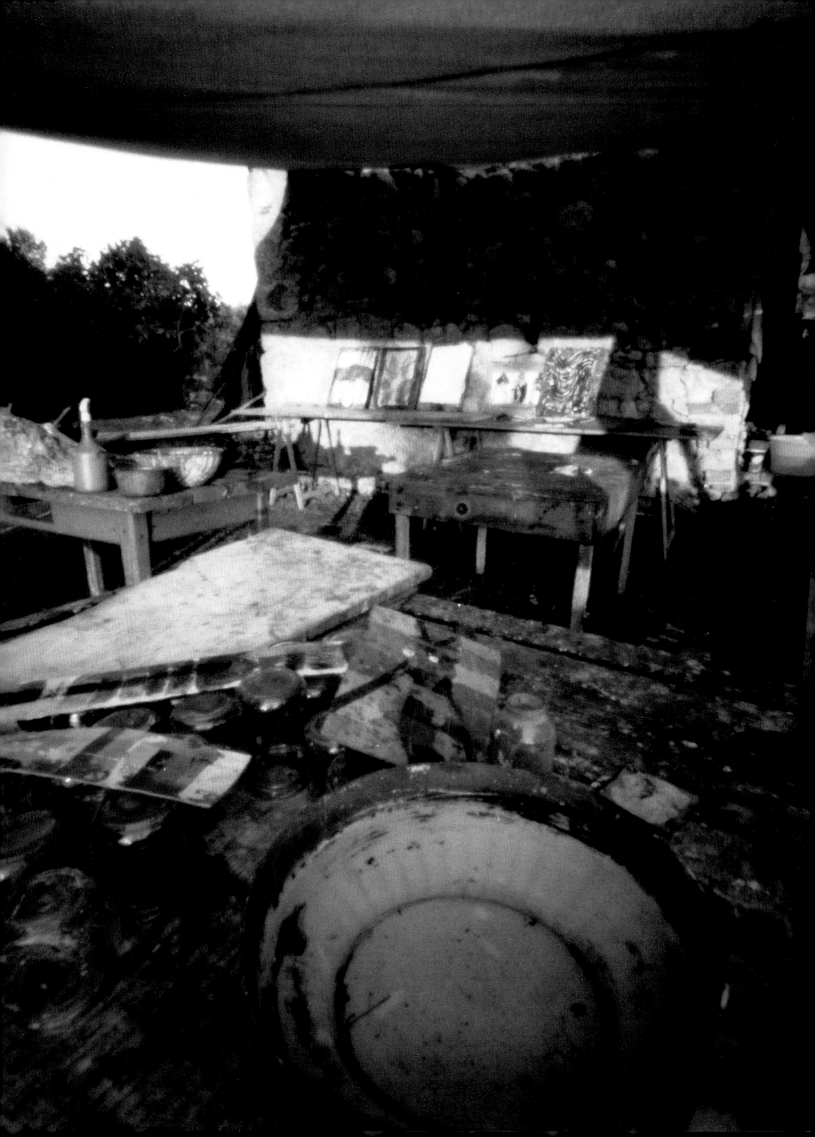

PHOTOGRAPHY BRIAN BUCKLEY

PRINTER TRIFOLIO

ISBN 978–1–944316–06–8

BILL JENSEN

TRANSGRESSIONS

DESIGN JOHN CHEIM

ESSAY DAVID LEVI STRAUSS

CHRONOLOGY MAGGIE WRIGHT

EDITOR ELLEN ROBINSON

CHEIM & READ, NEW YORK